IMAGES
of America
FOX ISLAND

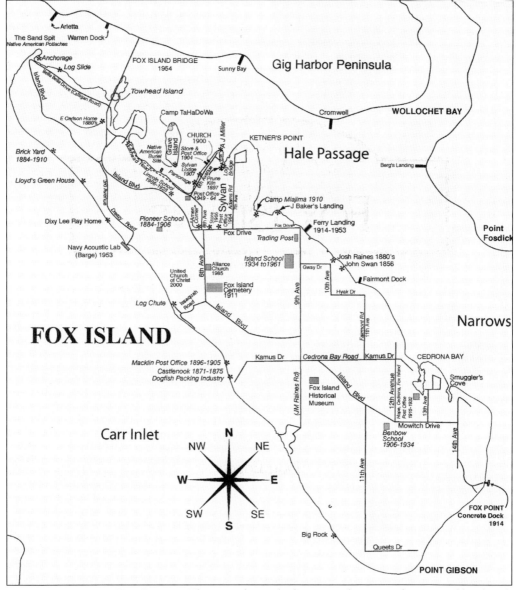

HISTORICAL MAP OF FOX ISLAND. This map shows the location of every settlement and landmark from 1856 to 2000, including the landmarks across Hale Passage and the present-day road system on the 1.5-by-5-mile island. (Courtesy of Dr. George Weis.)

ON THE COVER: From 1910 on, many visitors from Tacoma and beyond would gather on Fox Island for summer weekends to enjoy activities at a large Japanese tea house near this beach, called Boulder Beach. On Sunday afternoon, a steamer would land at a float beyond the boulders to return them to the mainland. (Courtesy of the Baker family.)

IMAGES
of America
FOX ISLAND

Don Edgers

ARCADIA
PUBLISHING

Copyright © 2008 by Don Edgers
ISBN 978-0-7385-5807-3

Published by Arcadia Publishing
Charleston SC, Chicago IL, Portsmouth NH, San Francisco CA

Printed in the United States of America

Library of Congress Catalog Card Number: 2007939181

For all general information contact Arcadia Publishing at:
Telephone 843-853-2070
Fax 843-853-0044
E-mail sales@arcadiapublishing.com
For customer service and orders:
Toll-Free 1-888-313-2665

Visit us on the Internet at www.arcadiapublishing.com

In memory of Fox Island's pioneers

Contents

Acknowledgments		6
Introduction		7
1.	Before There Were Roads	11
2.	Settlers, Settlements, and Industry	41
3.	The Ferry Years	75
4.	The Bridge and After	111
5.	Recently	121

ACKNOWLEDGMENTS

Fortunately the founders of the community of Sylvan on Fox Island thought to preserve the island's history through words and pictures as far back as 1897, when the Fox Island Historical Society (FIHS) was formed under the leadership of Andrew J. ("Joe") Miller. Because of the historical records kept by Emma Booker and Winnifred Booker Rasmussen, we are privy to history starting in 1889 to 1912. In 1959, Dr. Harold Hoover, Cecil Fassett, Doris Macdonald, Paul Bentley Sr., Elbert Law, and Dale Thompson restarted the historical society.

Cecil Fassett started collecting island artifacts, photographs, and documents with the help of Dale Thompson, Frances and Bill Ward, Viola Powers, Winnifred Paul, Fannie Peterson, Harold Young, Anne Nelson, Thelma Fassett, Lois and Paul Bentley, Dorothy Beals, Alvin and Elsie Schmidt, Eleanor Kibler, Doris Macdonald, Mildred Morris, Sandra Mowry, and Lois Miller. These artifacts are now in the Fox Island Historical Museum.

Contributors to the island's historical preservation are Dick and Addie Chapman, the Acheson family, David McHugh, Gene and Harold Fisher, Everett Hill, Bob Olson, Jim Menzies, Frank Guhr, Irl MacDuff, Harvey Newsome, Jack and Harriet MacDuff, Kenneth Hodgeboom, Marion Reid, Leslie and James Swick, Roy Jones, Barry Lowers, Orville Niesz's family, Carl Johnson, Barbara Buck, Esther McAfee, Jim Roupe, Georgia and Tony Moore, Harold Henry, Hannah Jay, Gene and Vera Hackett, Marge and Bob Bevin, Jane Scheulein, Betty Wickstrom, John Ohlson, George and Marie Weis, and FIHS members.

Carolyn Edgers was a valuable special assistant.

Publications contributing to the preservation of words and pictures are the following: *Fox Island—A History* by Alexis Macdonald (1966, 2006); *Grapevine* by Jan Smith and Jean Vandervelde (1974, 1975); *Fox Island Times* by Jan Smith, Jean Vandervelde, Jill Christ, Madge Hubbard, Phyllis Finkle, and Matt Ketchum (1976–1982); *Fox Island: Pioneer Life on Puget Sound* by Caroline Perisho (1990); *Fox Island—A History* by George Miller, edited by Beatrice and Loyd Walker (1993); *Echoes of Yesterday on Fox Island* by Chauncey Wight, edited by Marie and George Weis (2002); *An Island In Time: Growing up in the 1940s* by Don Edgers (2002); and *An Island In Time II: Coming of Age in the 1950's* by Don Edgers (2007).

INTRODUCTION

For hundreds of years, South Puget Indians of the Nisqually, Steilacoom, and Puyallup tribes made camp on Fox Island, which they called Bu Teu, meaning sea person. In the 1770s, Spanish explorer Don Jacinto Camano (Camano Island's namesake) christened the island Rosario. In 1792, British captain George Vancouver and Lt. Peter Puget explored the South Sound region, in search of the fabled Northwest Passage, and the island retained its Spanish name. The Americans sent a U.S. exploring squadron of six vessels under the command of Lt. Charles Wilkes, which began in 1838 to chart and explore waters as far south as Antarctica, north to the Straits of Juan de Fuca, and into Puget Sound, where he arrived near present-day Commencement Bay of Tacoma in 1841. It was at this time the island was bestowed with the name of Lt. (Dr.) John L. Fox, the assistant surgeon for the Wilkes Expedition.

Fox Island first made it into history books in 1856 because of the Indian War. The island became a temporary reservation for non-hostile South Puget Sound Indians. "Hostile" Native Americans were those who objected to the imposed restrictions of territory as written in the Medicine Creek Treaty, forcing the Native Americans to live on small reservations in unfamiliar territory. John Swan, an early-day settler and fish packer and exporter, who lived near Tacoma and dealt with the Native Americans, was appointed temporary Indian agent and supervisor. By building a cabin on the island, he became Fox Island's first settler. The treaty was rewritten and hostilities ceased, with Swan remaining in his new location on Fox Island's north side.

One half mile to the east of John Swan, oysterman William Spencer obtained a permit in 1869 to raise oysters in a high-tide inlet called Smuggler's Cove. On the south side of the island, Castlenook Fisheries (North Commercial Company) began operations in 1871 with 20 men who caught and processed an average of 3,000 dogfish a day. Shark liver oil was important for machine oil, and glue was made from the heads, tails, and fins. A short distance to the west of Castlenook was the start of a community originally named Guthrie Camp and later Macklin. This little community had a one-story hotel, a post office, and two doctors (John Donaway and Benjamin Allen) who treated white settlers and Native Americans alike. Dr. Allen was also the community's first postmaster, and his home is reported to be the first on Fox Island with indoor plumbing.

In early 1884, an even larger industry was founded two miles to the west, called the Fox Island Brick Manufacturing Company and in 1886 incorporated as the Fox Island Clay Works Company. It was one of the first brickyards in Puget Sound. At its peak of production, the company had 50 men and from 1906 to 1910 produced 15,000 bricks a week. By 1911, the clay deposits were nearly exhausted, nearby brickyards were fiercely competing, and concrete became the preferred material for construction. During the brickyard's tenure, it had become an early south-side community with a store, a post office, and a pier.

Because there were communities with children not attending school, Fox Island settlers constructed the Pioneer School (later named Sylvan School) located approximately halfway between Macklin and the Brickyard.

Sixty-nine-year-old Andrew Joseph Miller succumbed to the lures of Washington Territory as advertised in Iowan publications, promising warmer winters (1888 generated the Great Blizzard

of 1888 in the Northeast and the Schoolhouse Blizzard in the Great Plains), cooler summers allowing fruit and vegetables to grow rapidly, and an abundance of seafood and game. Land prices were an added bonus. In the spring of 1889, Miller, his son Edwin, and a Mr. Hutchins, a handyman, arrived via the stern-wheeler *Messenger* on a heavily forested peninsula that would evolve into the 56.5-acre community of Sylvan. Living in a 20-by-20-foot log cabin constructed 10 years earlier and subsequently used as an animal shelter, the three men spent a day shoveling out a foot or more of manure in order to make the building habitable. Thus a base of operations was made ready for other Iowa settlers who would soon join the community. The next settlers from Iowa arrived in Tacoma in the fall of 1889 and were Emma and Daniel Booker, Stephen Herrick, and Tilson Bixby and his daughter Belle. By 1891, three houses were habitable and the land was planted in fruit orchards. Sylvan's first baby, Paul Booker, was born in 1892. This also was the year that the next core family arrived on the point across from the Miller's, the Richard Ketners, who lived in Tacoma. The former Ohio immigrants became summertime residents, clearing the land up to the Bixbys', and in 1894 had a house that had been built in Macklin moved to their property. The next children to be born came in 1895 with the birth of the island's first girl, Anne, born to Eric and Hilda Carlson, who lived on the northwestern portion of Fox Island and raised 17 acres of strawberries. Sylvan's second birth was in the same year as the Bookers—a daughter, Winnifred. The Fox Island census counted 80 residents.

Starting in 1897, the Sylvan Fruit and Vegetable Evaporating Works (prune dryer) was built in the cove between Ketner's Point and Miller's Point. It was used to dehydrate prunes and other fruit from the orchards on Fox Island and surrounding communities on the mainland. The primary reason for the dehydration of fruit was that the Italian prune trees were bearing heavily, but there was no market for fresh fruit. The finished product was shipped as far away as Dakota, Iowa, Illinois, California, Oregon and even in New England. The next year, the fruit yield was so great that the dryer had to be expanded. Even onions were dried to send to the Klondike for the gold rush. In order to reach the prune dryer on Miller's Point from points east of Ketner's Point, a Douglas fir tree was felled across the cove between them. Planks were affixed to the top of the tree and a railing fastened to it, making it the first bridge on Fox Island.

The 18-acre Native American grave island, where the local Native Americans placed their deceased in canoes lashed in trees, was bought by a Tacoma mortician and county coroner, Conrad Hoska. He and his family planned to make the island a summer residence and put in an apple orchard. Grave Island was renamed Tanglewood by Helen Hoska, but Sylvanites tended to refer to it as Hoska's Island. As more settlers arrived, most of the settlement seemed to branch out on the island's north side to the east and west of Sylvan.

By 1900, Fox Island Congregational Church (established in 1892) had been built about 200 yards south of the Millers' home and a float for loading and unloading passengers was built at Miller's Point to accommodate steam-powered watercraft of the Mosquito Fleet. A parsonage was built 200 yards south of the church in 1903, and a year later, a dock with a store was constructed 50 yards south of the church. In 1905, a school called Benbow was built nearer the northeastern community of Hope. Before the dawn of the 20th century, groups of people would picnic and camp on the south side of Fox Island, and with steamboat excursions gaining popularity, the Ed Wines family decided to construct a lodge with camping cabins that could accommodate over 50. The Sylvan Lodge was erected to the north of the parsonage, and by 1907, tourists came flocking in. Now there were four (including Tanglewood Island) landing places in Sylvan for steamers to land. There were 60 houses by 1908, according to the timber maps at that time, and there was a rough road or pathway extending from the west end of Fox Island to the east end. In 1909, the Lincoln School near Sylvan Bay was opened.

In 1910, the YWCA purchased a Japanese teahouse that was used for the Formosa Exhibit at the 1908 Alaska-Yukon-Pacific Exposition in Seattle. The teahouse was dismantled and reassembled near the Baker's Cove area, east of Ketner's Point. The building, named Camp Miajima, was used for a Girl Guides camp and community gatherings for another 20 years.

As more visitors continued coming to Fox Island, three more landings were built on the

island's north side. By 1914, in addition to a float at the YWCA camp, permanent docks were built to the east of Camp Miajima at what was to become the ferry landing at Fairmont and at Fox Point at the eastern end of Fox Island. The Fox Point Wharf, made of concrete, became known as the Concrete Dock. Located in the Narrows where the tidal current ran strong, it had to be abandoned for safety reasons. When the ferry landing was completed, the vessel *Transit* went into service, carrying up to six Model T–type automobiles on its upper deck, which upon landing tried to meander the barely usable one-lane dirt roads. By 1920, the road system had improved on Fox Island and throughout the United States, and travel by boat was waning. One tourist who visited Sylvan for the month of July 1921 was future movie actor Spencer Tracy. He was the guest of the Dr. Eben Edgers family, whose son, Kenneth, was his college roommate in Ripon, Wisconsin, during the school year.

Logging and farming continued to thrive, and a two-acre greenhouse known as Lloyd's Greenhouse did a booming business. A second large store named Fox Island Trading was built by the ferry landing. Flower bulbs became another agricultural-type business, and the Peter Cooks, who owned and farmed the Miller homestead, planted grapes for export to a winery on Stretch Island. Lincoln School in Sylvan closed in 1928, and students had to be transported to the Benbow School by Hope, now called Cedrona Bay.

In the 1930s, the Great Depression took its toll on the Sylvan Lodge's business, and the Ed Ericksons from North Dakota took it over and operated it on a limited basis. Electricity came to the island via an underwater cable from Cromwell to Ketner's Point, and the Sylvan Lodge became the first structure to have electric lights. The Hoskas, who owned Tanglewood Island, sold the island to Dr. Alfred Schultz, a Tacoma pediatrician who planned to build a summer camp for boys. The Civilian Conservation Corps of the New Deal was put to good use, and Fox Island men built a permanent cement bulkhead along the road that skirted Sylvan Bay (renamed Echo Bay) and also cleared ground for a new school, the Island School, which was more centrally located. The 29-year-old Benbow School closed. The post office at Cedrona Bay, officially named the Fox Island Post Office, also closed at this time after 19 years of operation. All the mail went to the Sylvan Post Office from then on. The Fox Point Nursery began operating in 1937 at the eastern end of the island.

Dr. Kenneth Edgers, a Seattle dentist, bought the Miller's Point property from Anna Cook in 1944 and continued harvesting the Island Belle grapes until the winery that bought them closed in 1947. Dr. Schultz's plans to turn Tanglewood Island into a camp for boys came to fruition when Ed Erickson and his Fox Island construction crew built Camp TaHaDoWa, meaning "Welcome" in the Native American language, in 1946. The Sylvan Store and Post Office closed in 1949, and the post office relocated to the junction of Sylvan Road and Bulkhead Road on Echo Bay.

In 1953, a phone line was installed at the Fox Island Trading Post at the ferry landing. A year later, the 1940 ferry, the *City of Steilacoom*, was replaced by a cement bridge that extended from Towhead Island (500 yards west of Tanglewood Island) north to Warren. Meanwhile, on the island's south side, the U.S. Navy opened a facility to test submarine acoustics. The initial facility was a large anchored barge, dubbed by Islanders "the Navy Barge." The DeMolay (a Masonic youth organization), which had bought the former Native American potlatch area called Sandspit, constructed a building on the site. The first home, built in Sylvan by A. J. Miller, was demolished in 1956.

The Island School closed in 1961, and the building became a community center named for longtime resident, businessman, and community leader Col. Fred Nichols. A boat-gas dock also started the same year at the old ferry landing, and the store moved to the top of Amen Hill in 1966. The post office had moved to this area in 1964. Both facilities happened to be on the southern border of the original Sylvan community. The vacated Fox Island Trading Post became a bait herring packing plant. The Fox Island Yacht Club located in Cedrona Bay (Hope Bay) started in 1965. The superintendent's home for the Fox Island Clay Works Company, located at the top of the hill to the Brickyard, was made into a secondhand store called the Barn Sale, open one weekend a month starting in 1969.

In 1972, the store closed for a few weeks, reopening as Quick Stop. In 1976, it changed its name to Fox Island Trading Post. The Fox Island Dump, which began operation at the old Benbow School site in 1940, closed in 1976. Dr. Dixie Lee Ray lived on the island on beach property bordering the navy barge in the 1970s and became Fox Island's most famous personality when she became the state of Washington's first female governor. Marion Reid, her sister who lived on Fox Island, was Dixie's secretary and official hostess. Governor Ray retired to the island in 1980 and passed away in 1994.

The Christian and Missionary Alliance Church of Fox Island built a 20,000-square-foot facility 150 yards to the east of the store in 1985, and the United Church of Christ built a new church across from the cemetery in 2000. The original Fox Island Congregational Church built in 1900 is being used as a wedding chapel and for cultural events.

One

BEFORE THERE WERE ROADS

There were no roads on Fox Island until the early 20th century. Boat travel was the main mode of transportation. Along the island's northern shore were animal trails used occasionally by local Native Americans.

In 1856, fish buyer/packer/exporter John Swan was appointed as Indian agent to Fox Island's temporary reservation during the Indian War, and he became the first permanent settler. A half of a mile to the east of Swan was a small high-tide inlet known as Smuggler's Cove, which was settled in 1869 by oysterman William Spencer. Two years later, a small community on the south side known as Castlenook was inhabited by 20 fishermen. Toward the southwest end of the island, an area called the Brickyard began in 1884. The community of Sylvan-Glen commenced in 1890 and developed into a thriving neighborhood that was a port of call for boats in the Mosquito Fleet.

Until a road network connected one end of the island to the other, there were separate post offices and schools located at the Brickyard, Macklin, Castlenook, Sylvan, and Hope. In order to attend the Fox Island Congregational Church built in 1900 in Sylvan-Glen, those living in other parts of the island had to travel by boat, ride a horse, or walk on trails until the 1920s. Because Fox Island is less than five miles by one and a half miles at its farthest points, traveling to the separated communities was not an overwhelming task—just time consuming.

The only store until then was located in Sylvan-Glen, as was the popular tourist destination the Sylvan Lodge, started in 1907. Another gathering spot was the YWCA Camp Miajima, better known as the Japanese Teahouse, which was built for the Alaska-Yukon-Pacific Exposition in Seattle in 1908. The two-story building was taken apart and reassembled in Baker's (B) Bay in 1910 where there was a long float where steamers and other boats could tie up. The Sylvan Store, built on a dock and landing for steamers in 1904, constructed a larger store on land in 1914.

Then came a ferry.

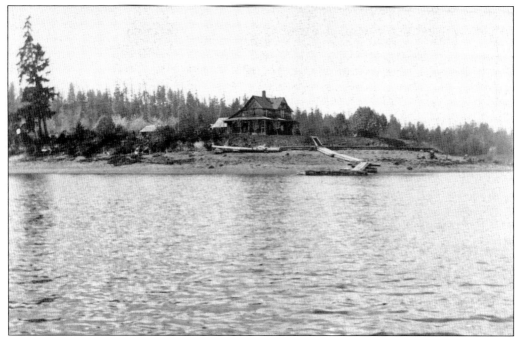

MILLER'S POINT. In 1890, the first house built in the Sylvan-Glen community was constructed for the Andrew J. Miller family by Andrew, his son Edwin, and a carpenter, a Mr. Scott. After the house was completed and others were built nearby, a landing and float were built to accommodate steamships carrying passengers, mail, and freight coming to and leaving the settlement. (Author's collection.)

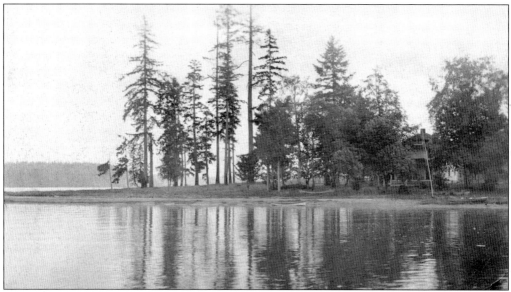

KETNER'S POINT. When the Ketner family first bought the property in 1892, Richard Ketner thought the point should be named Point Comfort. After a house had been moved from the opposite side of Fox Island to the property in 1895, there were so many girls around, it was usually called Old Maid's Retreat by Richard Ketner. When an apple orchard was producing lots of apples, it was referred to as "Orchard Croft." (Courtesy of the FIHS.)

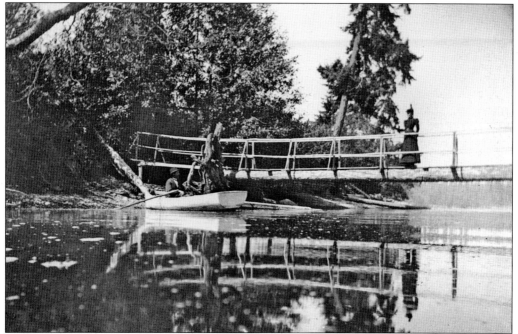

THE SHORTCUT. This Douglas fir tree was purposely felled in 1890 in order to make a shortcut for Tilson Bixby on Ketner's Point to get to the Millers on the opposite side of the cove. The bridge was made more usable by planking its top and adding a railing. It had a 40-year lifespan. (Courtesy of the Bixby family.)

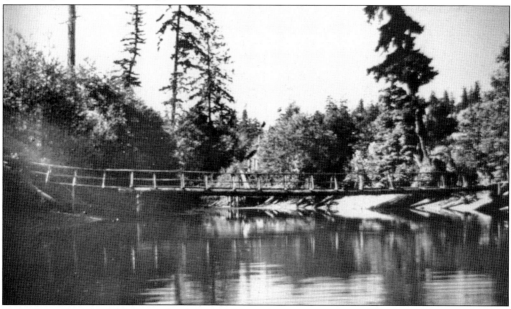

THE TREE BRIDGE. This tree bridge was the earliest connection of Ketner's Point to Miller's Point, where the community of Sylvan-Glen was located. The water under the bridge was only there at high tide, but the Bixby children were forbidden to walk across then, lest they should fall in the water and drown. Once a Bixby girl did fall off the bridge and got stuck in the mud of the cove. (Courtesy of the FIHS.)

AMEN CORNER. At the top of the hill bordering the southeast end of the community of Sylvan was a turn in the road called Amen Corner, so-called because parishioners on rainy Sundays had to struggle up the muddy hill and would exclaim "Amen!" when reaching the summit. The Sylvan Road extended from the church to as far as Fairmont Landing, two miles away. This corner is now Sixth Avenue and Fox Drive. (Author's collection.)

THE SYLVAN BAY ROAD. The barely discernable wagon tracks on the left show how dependent the early settlers of Sylvan were on Puget Sound to enable them to travel from one house to another. Behind the bushes and tree is the Herricks' house, built in 1891. (Courtesy of the FIHS.)

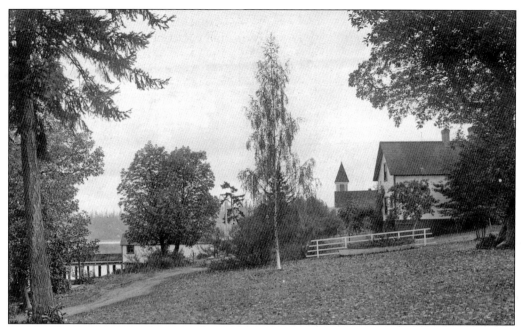

Sylvan Scene. In 1910, this was what the western waterfront of Sylvan Bay looked like from the Sylvan Lodge to the dock and church. The Laurels is the first house on the right. Only a trail runs along the shore at this time. (Courtesy of the Erickson family.)

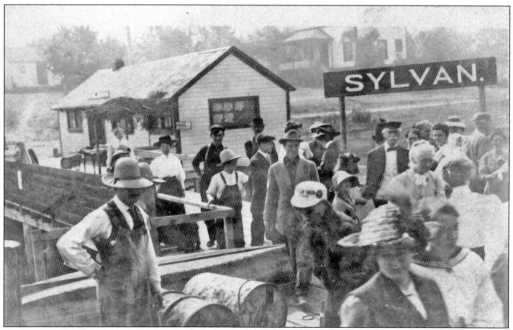

The Sylvan Dock. From the time it was built, the Sylvan Dock, which also had a general store and post office, was used by Fox Islanders as a staging area to catch steamboats of the Mosquito Fleet to get around Hale Pass and into the city of Tacoma or other points in South Puget Sound. (Courtesy of the FIHS.)

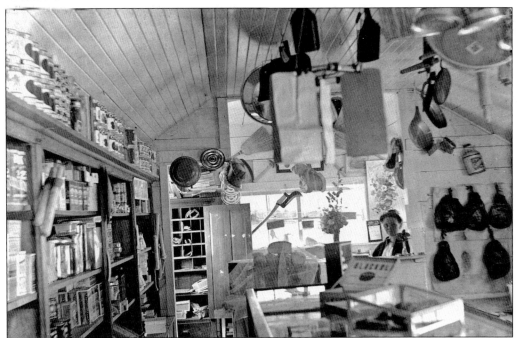

INSIDE THE SYLVAN STORE ON THE DOCK. The dock and store, which were built in 1904 by Charles Johnson, sold a year later to George Pierce. His wife, Jenny Pierce, is seen on the right. The post office in the Bixbys' home and another in the Macklin community were consolidated to Sylvan. Groceries were delivered all around Sylvan Bay and Hale Passage by a delivery boat owned by the Pierces, the *Fernacre*. (Courtesy of the FIHS.)

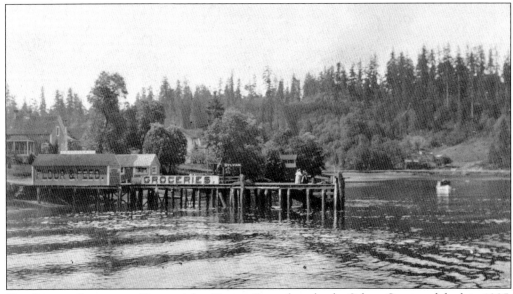

THE SYLVAN STORE AND DOCK. After George Pierce bought the Sylvan Store and dock in 1905, he added a small warehouse, and his wife, Jenny, was the postmistress. Business became so brisk that a second delivery boat, the *Fernacre II*, was added. The Pierces' profitably ran the business for another 13 years. When they sold the business, they moved to Fox Point at the eastern end of Fox Island. (Courtesy of the FIHS.)

BOATHOUSE ON SYLVAN BAY. In 1904, when the Fitch family built the Laurels, they also built a boathouse over Sylvan Bay in front of their residence. It had room for a boat, four changing rooms, and a covered party-type room on a second story. (Courtesy of the FIHS.)

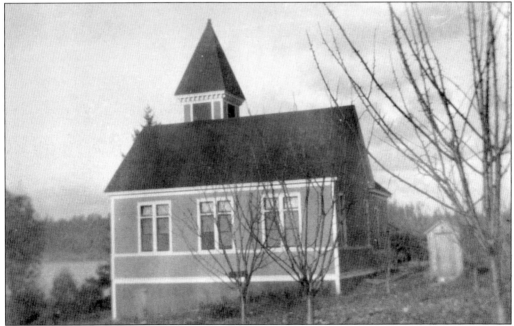

CHURCH WITH AN OUTHOUSE. During its early years, the church didn't have indoor plumbing, so an outhouse was in place. The main building was heated with a potbellied stove that took two hours or more to warm the sanctuary in winter weather. Electricity came after 1931. (Courtesy of the FIHS.)

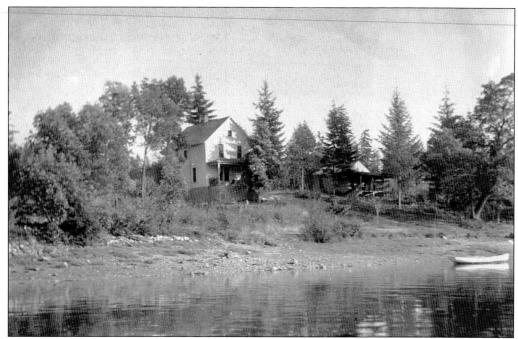

THE PARSONAGE. The parsonage for the Fox Island Congregational Church was built in 1903, based on 26-year-old Ray Bixby's design. The property was sold to the church by Tacoma winter resident Alice May Merrill for $100. A property and building fund had been established in 1902. The property and house was located between the Bookers' (which became the Sylvan Lodge) and Leavens' residences. (Courtesy of the FIHS.)

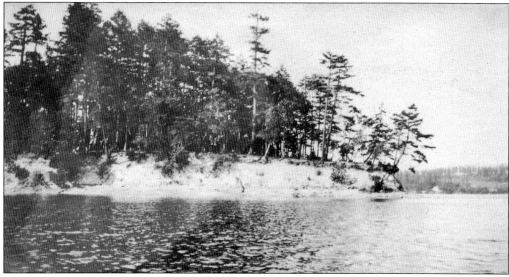

NATIVE AMERICAN BURIAL SITE. Until 1895, this 18-acre island was used by local Native Americans as a burial site. Some Northwest Indian tribes, like the Nisqually, placed their dead, along with some of their belongings, in a canoe with drain holes. The canoe would be fastened to trees up to 12 feet off the ground and remain there for eternity, or until the Smithsonian Institution claimed it. After that time, the Conrad Hoskas bought the former Grave Island and named it Tanglewood. (Author's collection.)

CASTLENOOK. The North Pacific Commercial Company, better known as the "dogfish business," operated at this site from 1871 until 1875. They caught and processed an average of 3,000 dogfish (spiny dogfish shark) a day with a 20-man crew. The livers made fine oil; the heads made glue; the fins and tails were exported to France for food. (Courtesy of the FIHS.)

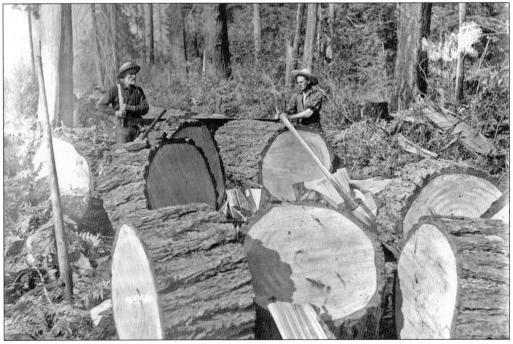

CLEARING THE FORESTS. Norman (left) and Dan Buck had to cut fireplace-size sections out of trees that could not be skidded to a skid road and on to Sylvan Bay or BB Cove. Land clearing was difficult and backbreaking labor but necessary to prepare Fox Island for agriculture. (Courtesy of Barbara Buck.)

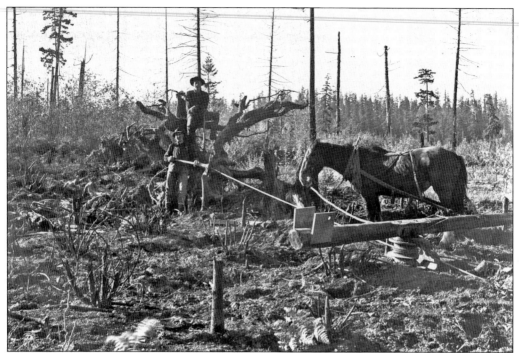

PULLING STUMPS. In order to prepare the island for orchards, crops, and building sites, the Buck brothers use their horse and a stump remover to clear the stumps of logging leftovers. The stumps were first "loosened" with dynamite. Much of Fox Island was logged by 1900, and agriculture became a dominant industry because of the land cleared by the Bucks and others. (Courtesy of Barbara Buck.)

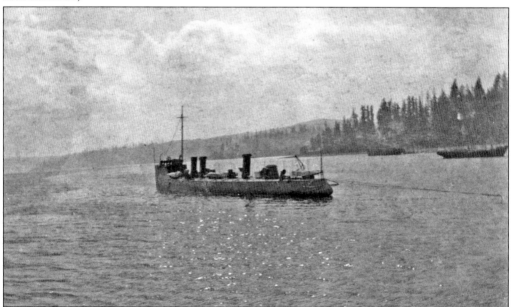

THE POLITKOVSKY. In the early days of logging on Fox Island, this little steamer was used to pull rafts of logs from the island to lumber mills on the tide flats in Commencement Bay in Tacoma. (Courtesy of the FIHS.)

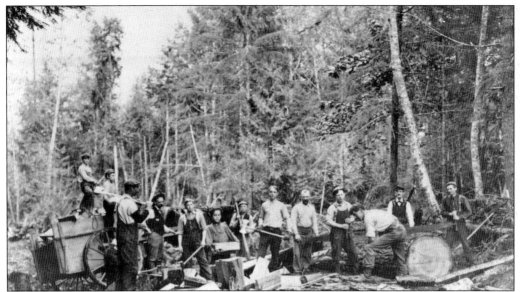

WOOD BEE. Community service was performed by all able-bodied men attending the Fox Island Congregational Church. The winter supply of firewood for the church and parsonage was provided from the wood cut and split during wood-cutting bees. One large tree normally provided several cords of firewood. (Courtesy of the FIHS.)

THE CARLSON FARM. Eric Carlson bought property above the bay to the west of Sylvan Bay and near Towhead Island in 1888. He had a job at the smelter in Tacoma but worked on clearing his land and building a house here until 1895. After moving here, he became a farmer. The first white girl on the island, Anne Carlson, was born in this house. (Courtesy of the Nelson family.)

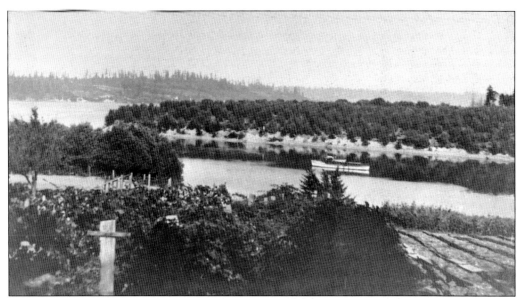

ACROSS FROM SHOREWOOD. In 1910, the Carlsons' berry farms were bordered by grapes and a fruit orchard. The land across the small bay became know as Shorewood. On the other side of Shorewood is the west side of Sylvan Bay and a cove called Packard's Cove. (Courtesy of the FIHS.)

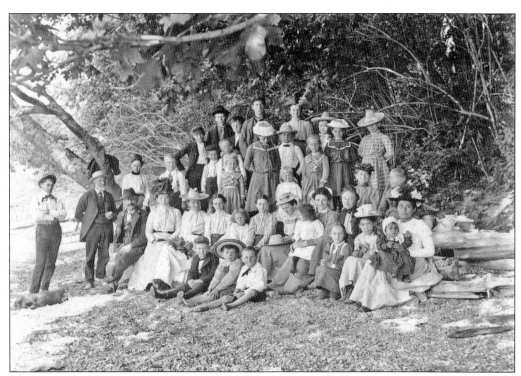

CHURCH PICNIC. In the early 1900s, the Fox Island Congregational Church's families would get in boats, ride horses, or walk to the Sandspit. They would dig for geoducks and bring other picnic vittles to be consumed in the same spot Native American potlatches were held for many previous decades. (Courtesy of the FIHS.)

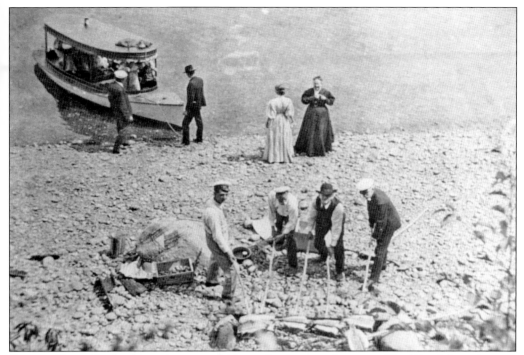

SALMON BAKE. Seafood was always available on the shores and waters of Fox Island, but a favorite seafood feast, salmon, brought out a crowd of picnickers. As the salmon bakers tend to the fish on the embers, a launchful of people awaits the outcome. (Courtesy of the FIHS.)

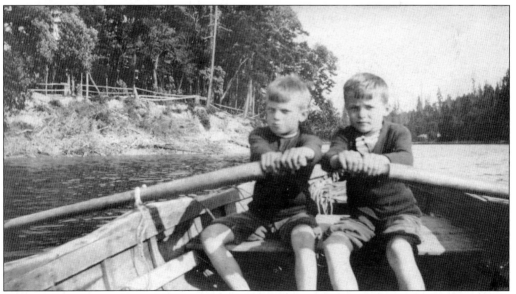

ROWING BROTHERS. Around 1910, Kenny (left) and Newton Edgers put their backs into getting around the grave end of Grave (Hoska's) Island on their way back to the Sylvan Lodge, where both boys spent their summers with their mother and sister. Their father was a dentist in Seattle, spending only weekends at the lodge. (Author's collection.)

SYLVAN WEDDING. After an eight-year engagement, Carrie Herrick and Arthur Dennis became Sylvan's first couple to marry on July 29, 1905. Carrie had come with her parents to the island 24 years earlier. The sleigh was originally used to move boulders, but it served well as a horse-drawn wedding carriage to see the two transported to the stern-wheeler *Tyrus*. The dark horse is led by Daniel Booker and the other by Edwin Miller. (Courtesy of the Fischer family.)

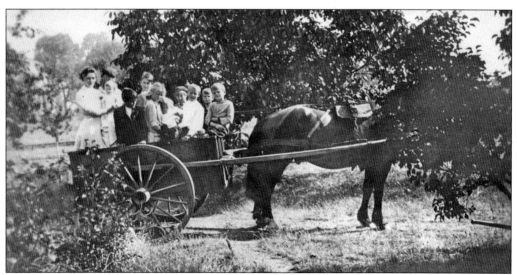

HORSE-CART TAXI. In the event that a cart used to carry freight, fruit, or firewood happened to be empty, it was an open invitation for anybody in the neighborhood to hop in and take a short ride to no place in particular. All ages participated. (Author's collection.)

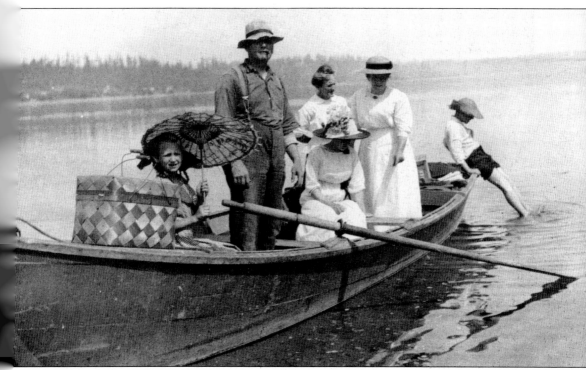

SANDSPIT PICNIC. Shown here from left to right in about 1910, Francis Ward, George Buck, Alberta Buck, Nellie Adams, Sue Baker, and Eugene Buck prepare to disembark their rowboat to have a picnic at the Sandspit of Fox Island. This tip of land on the northwest end of Fox Island was a popular place for picnics and was also used for Native American potlatches for hundred of years. (Courtesy of the Buck family.)

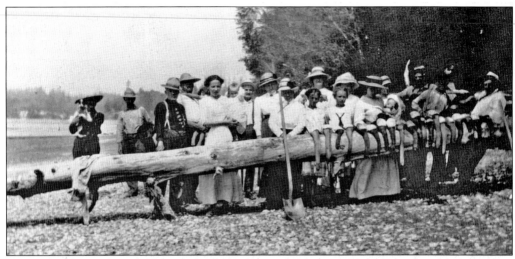

BB Bay Duck Diggers, 1913. On the occasion of a low tide during summer weekends, BB (Baker/Buck) Bay families and their city friends would head to the island's south side in order to engage in the sport of geoduck digging. Here the Bucks, Bakers, and their friends display the day's catch, which would be prepared later on the north side of Fox Island. (Courtesy of the FIHS.)

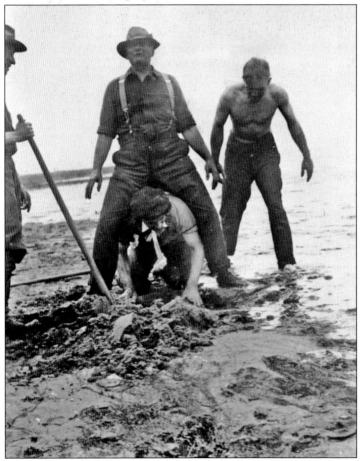

Digging Ducks. Geoducks, large clams, have been a food source on Fox Island since it was first settled in 1889. George (center) and Gene Buck (right), both with their arms spread wide, work with others to capture the quick-digging bivalve. (Courtesy of Barbara Buck.)

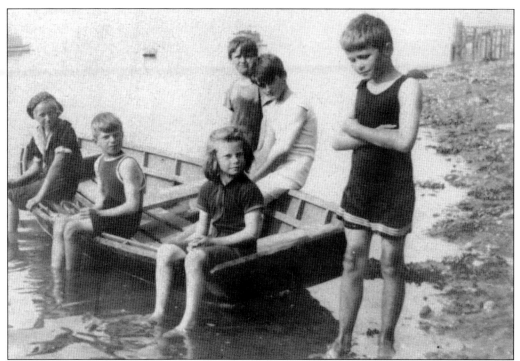

SWIMMING KIDS OF SYLVAN. In the 1910s, the swimmers in Sylvan Bay were divided into the "feet danglers" and the "real swimmers" because of the frigid water temperatures. Kenny Edgers, on the right, developed into a "real swimmer" for the rest of his life. In retirement on Fox Island, he went swimming in the sound every day year-round until his death in 1979. (Author's collection.)

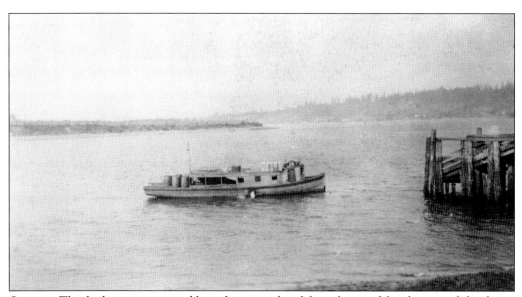

CYRENE. This little steam-powered launch was used to deliver fruit and freight around the shores of Hale Pass and Carr Inlet. This photograph shows it by the Fox Island Ferry Dock. (Courtesy of the FIHS.)

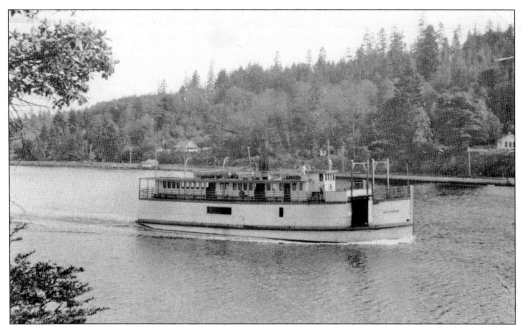

The Arcadia. Cruising in Echo Bay, between Tanglewood Island and the south Sylvan Bay shoreline, this freight boat was built in 1929 in Tacoma for Capt. Ed Lorenz, who had piloted stern-wheelers to Fox Island as early as the 1890s. The vessel is diesel powered and propeller driven and still in operation in the 21st century as the *Virginia VI*. (Courtesy of the FIHS.)

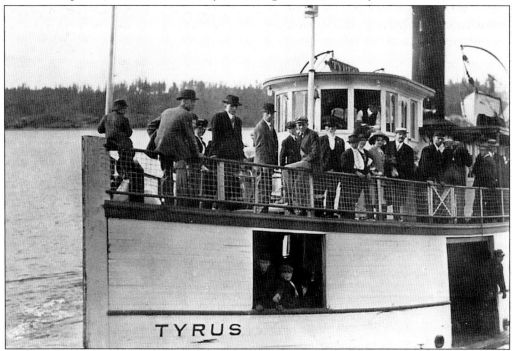

The Tyrus. This 108-foot propeller-driven craft was built in Tacoma for the Lorenz brothers in 1904. The *Tyrus* made a thrice-weekly trip to Fox Island. It is seen in this picture coming into the Sylvan Dock. In later years, this ship was renamed *Virginia IV*. (Courtesy of the FIHS.)

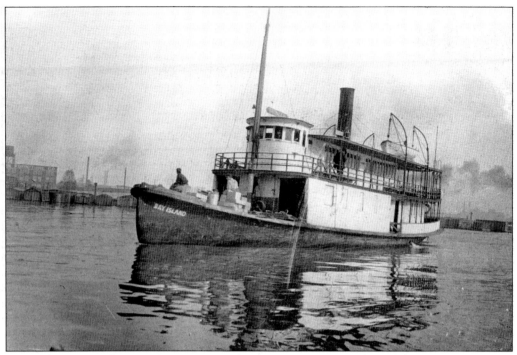

THE BAY ISLAND. The Hunt brothers built this 100-foot steamer and named it the *Crest*. In 1914, she was bought by the Producer's Union (fruit and vegetable producers) and renamed the *Bay Island*. When fully loaded, this steamer was very fast, as proved in the Tacoma Narrows when it raced the steamer *Dix* and easily beat the competitor to Tacoma. The ship operated until 1929. (Courtesy of the Hunt family.)

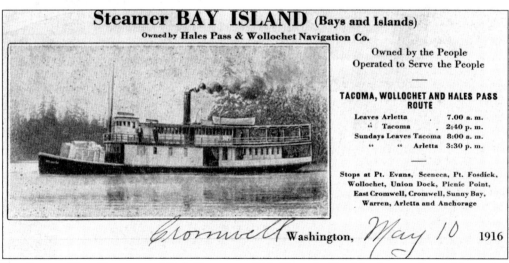

BAY ISLAND TIME SCHEDULE. With 11 stops on Hale Pass, the *Bay Island* not only quickly carried fruit and produce for the Producer's Union, but picked up and dropped off passengers along her route. At the end of the day, the vessel tied up at Anchorage at the Sandspit on Fox Island. (Courtesy of the FIHS.)

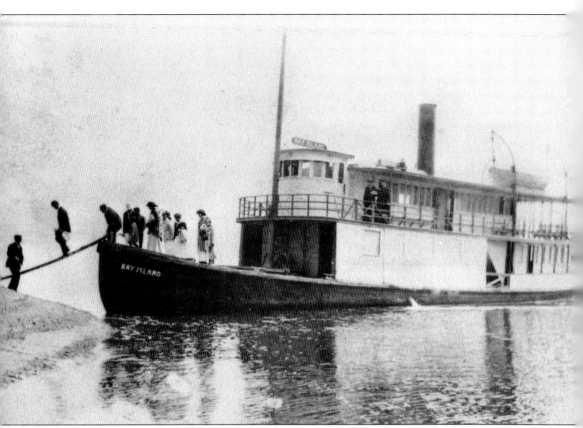

BAY ISLAND AT THE SANDSPIT. This picture shows passengers unloading at Fox Island's Sandspit at Anchorage, where she anchored overnight because the skipper, Capt. Floyd Hunt, lived there. At the end of each day, the firewood to heat the steamer's boilers was delivered down a log chute from a hill at Anchorage. The craft was also captained by the island's Tom Torgeson in later years. (Courtesy of the FIHS.)

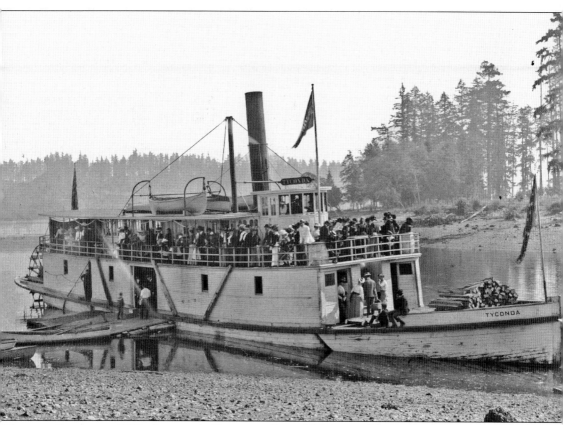

TYCONDA LOADING, 1901. As a goodwill gesture, Capt. Ed Lorenz of the stern-wheeler *Tyconda* would take Fox Islanders from his regular stops around the island for a day-trip around South Puget Sound. This particular photograph was taken from Miller's Point Landing, with Ketner's Point visible to the right and the mainland to the left in the background. (Courtesy of the FIHS.)

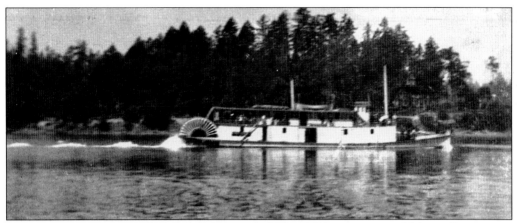

STERN-WHEELER IN SYLVAN BAY. A common sight before 1908, steamers would drop off passengers at the Sylvan Lodge, then head across Hale Passage to the Warren Dock. Behind this vessel and visible just above the bow is the Hoskas' house on Tanglewood Island. (Courtesy of the FIHS.)

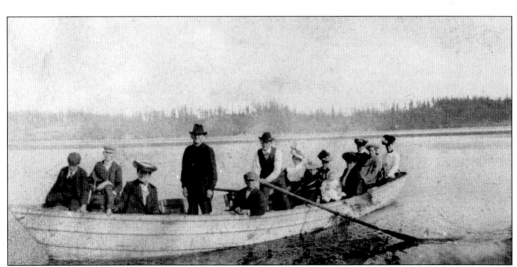

ROWING THE TYCONDA. This boatload of passengers was being ferried to the stern-wheeler steamship *Tyconda* in the years before a float with a ramp had been built in B Bay. James Baker (the namesake of B Bay) is seen standing in front of the oarsman. (Courtesy of the Baker family.)

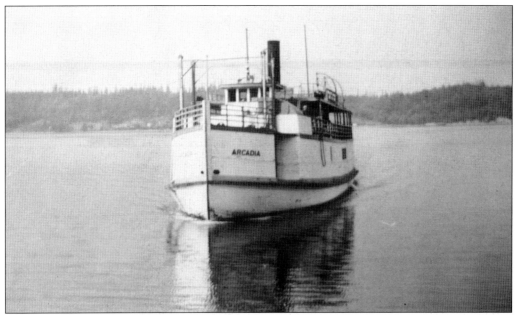

THE ARCADIA. Built in 1929, the steamer *Arcadia* was piloted by Fox Island's Capt. Tom Torgeson and served mostly in the North Sound. In 1942, she was renamed *J. E. Overlade* and used for 15 years as a McNeil Island transport in the South Sound. Still in operation, her name is now the *Virginia VI*.

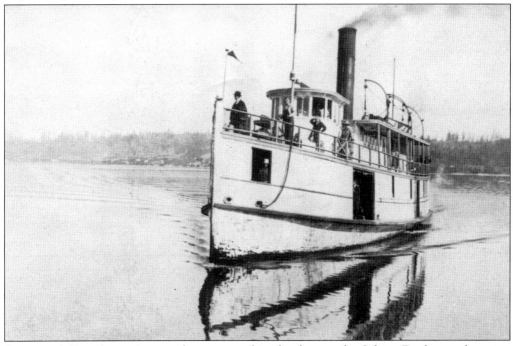

STEAMSHIP LANDING. A steamship coming for a landing at the Sylvan Dock was always an exciting occasion. A ship's schedule was strictly adhered to, so a minimum amount of time was spent unloading and loading passengers, mail, and freight. The only things that interfered with a schedule were weather and fog. (Courtesy of the FIHS.)

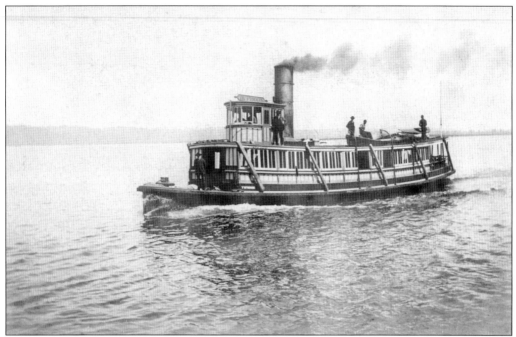

THE OLD TYPHOON. This smaller, propeller-driven steamer plied South Puget Sound waters and was a familiar sight off Fox Island in Hale Pass for nearly 15 years. She was primarily used to haul freight and occasionally passengers from landings around the area to and from Tacoma. (Courtesy of the FIHS.)

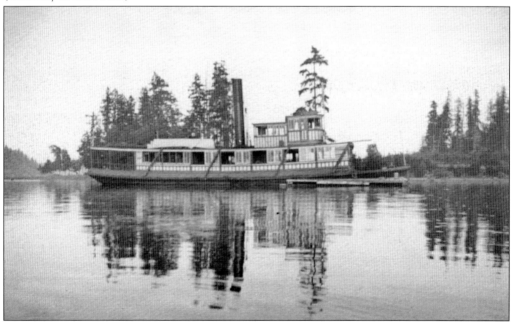

TYPHOON AT REST. Built in Portland, Oregon, in 1889, this 75-foot, propeller-driven river steamboat was brought to Puget Sound by the Lorenz brothers. She served as a freight, mail, and passenger boat until 1904. This photograph shows her anchored between Miller's Point and Ketner's Point. (Courtesy of the FIHS.)

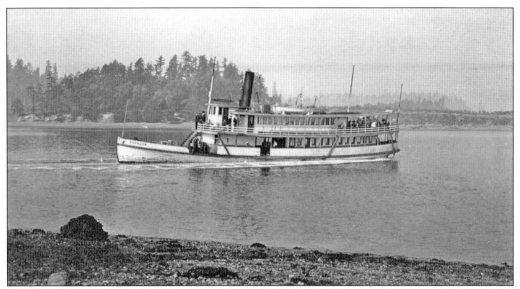

THE NEW TYPHOON. Built in the 20th century, this two-decked streamlined steamer was primarily used for passengers, unlike the freight hauler *Typhoon I* of earlier years. She can be seen backing away from the float at the Sylvan Lodge and into Sylvan Bay. Tanglewood Island is seen in the background. (Courtesy of the FIHS.)

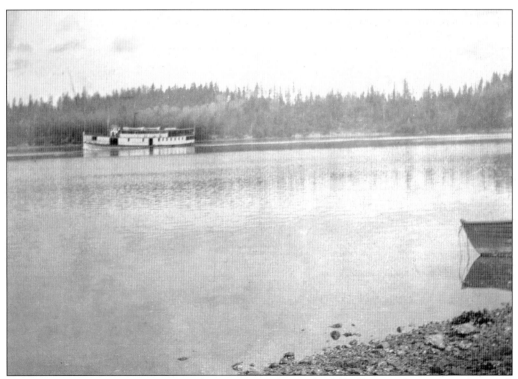

STEAMER PASSING BY. Throughout the summer and into the fall, all sorts of Mosquito Fleet craft could be seen in Hale Pass, sometimes passing by Fox Island, and steaming into Carr Inlet to stop near Arletta, Rosedale, Horsehead Bay, Home, or McNeil Island. (Courtesy of the FIHS.)

SYLVAN SCHOOL
SYLVAN, Pierce Co., WASHINGTON

1902 – 1903

PUPILS

Lottie Carrel
Winnifred Booker
Anna Carlson
Herman Fischer
Clarence Bixby
Bernice Owens
John Botnen
Hazel Carlson
Earl Steuby
Mamie Owens
Paul Booker
Ora Steuby
Frank Carlson
Leona Steuby
Beulah Steuby
Clarence Middaugh
Ray Steuby

Presented By
Sadie M. Peterson
Teacher

SCHOOL ROSTER, 1902–1903. From 1884 until 1908, the Pioneer (Sylvan) School was the only school on Fox Island. Seven-year-old Calvin Dempsey was warned by his father, "When they let you out, don't play along the road, because the bears might get you." Some children had to walk three miles on pathways through the woods in order to reach the school, but those who persisted were on this roster. (Courtesy of the FIHS.)

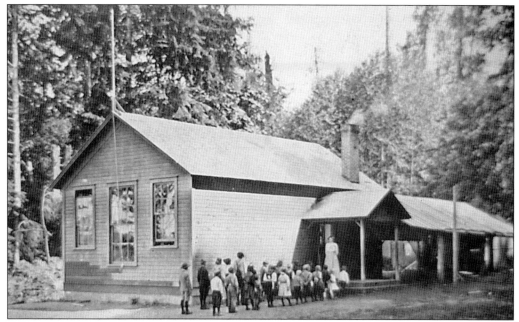

LINCOLN SCHOOL. The Pioneer or Sylvan School, located at the center of the island, was inconvenient for pupils living near Sylvan. The Lincoln School was built above Sylvan Bay and across from Tanglewood Island in 1906 in order to accommodate children of the northwest end of Fox Island. This school closed in 1928 and became a private home that is still occupied. (Courtesy of the FIHS.)

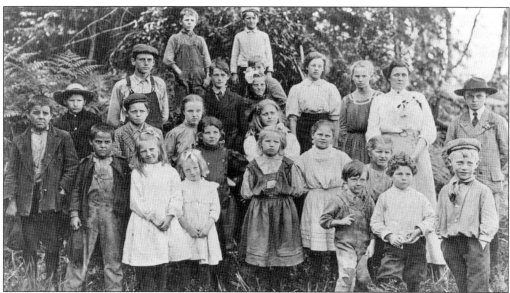

LINCOLN SCHOOL STUDENTS. This photograph was taken between 1908 and 1911 during a Lincoln School outing. The teacher, Charlotte Driscoll, is the second from the right in the second row. The Lincoln was built in 1906 to accommodate school students living on the west end of the island. Benbow School was for the island's eastern-end students. (Courtesy of the FIHS.)

LINCOLN SCHOOL GRADUATES. The eighth-grade graduating class of 1911 is, from left to right, Marie Nelson, Paul Bentley, and Lottie Carrol. Their teacher was Charlotte Driscoll. Paul Bentley would come back to Fox Island in later years to buy and live in the former Lincoln School. (Courtesy of the Bentley family.)

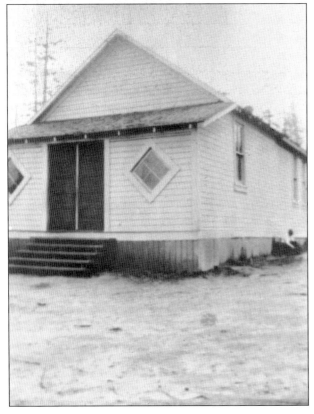

BENBOW SCHOOL. Named for county school superintendent L. L. Benbow, this new school was built to serve the schoolchildren at the eastern end of the island. The Pioneer (Sylvan) School was located on property that required some children to walk nearly three miles on skid roads or trails. The Benbow School building was very close to the community of Hope (Cedrona Bay). (Courtesy of the FIHS.)

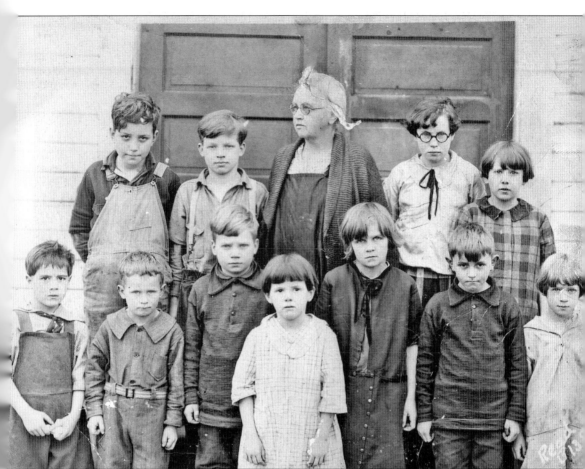

BENBOW SCHOOLCHILDREN. The Benbow School was located above Hope (Cedrona Bay) from 1908 to 1934 and was the only school from 1929 to 1934. The students and their teacher are, from left to right, (first row) George Smedley, Lloyd Carlson, Leonard Carlson, Gladys Carlson, Ollie Smedley, Jimmy Phil, and Margaret Botnen; (second row) Barney Gantz, Henry Botnen, Ella Smith (teacher), Jacqueline Miller, and Ruth Smedley. (Courtesy of the FIHS.)

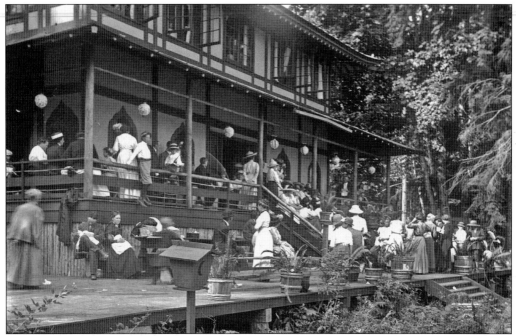

YWCA CAMP MIAJIMA. Known as the Japanese Teahouse, or "Little Tokyo," the structure was a popular gathering spot from 1910 into the 1930s. The building was originally built in 1909 for the Alaska-Pacific-Yukon Exposition in Seattle. Donated to the YWCA, it was reassembled in Baker's Cove on the island's north side, where it was used as a Girl Guides camp and a community gathering spot. (Courtesy of the FIHS.)

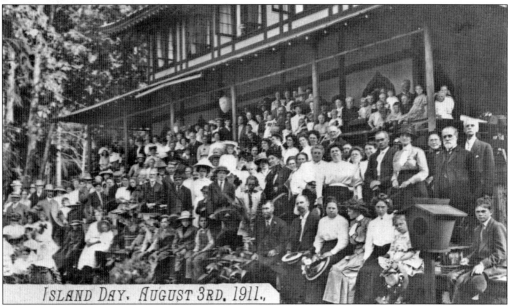

THE JAPANESE TEAHOUSE. The YWCA Camp Miajima became a big draw for Fox Islanders for Island Day in 1911, only a year after it was brought in pieces from the 1909 Alaska-Yukon-Pacific Exposition in Seattle. The YWCA bought property in BB Bay, where the structure was reassembled a short distance from the beach. (Courtesy of the FIHS.)

Two

SETTLERS, SETTLEMENTS, AND INDUSTRY

Before 1890, those who settled on Fox Island came to the island because of its abundant natural resources of trees, dogfish, seafood, and clay. In the 1850s, John Swan, the island's earliest resident, bought salmon from the Native Americans that was then packed and shipped throughout the United States and Canada. From 1871 to 1875, several million dogfish were processed for oil and food in the south central settlement called Castlenook. A few hundred yards to the west was a settlement called Guthrie Camp (later it became Macklin), where there was a single-story hotel, a post office, and two doctors. The community known as the Brickyard manufactured millions of bricks and other clay products from 1884 to 1910, and they had a store and post office. Josh Raines became Fox Island's earliest landowner and logger in 1882. He logged and farmed on the island for 25 years.

When Andrew J. and Edwin Miller, Stephen Herrick, Tilson and Ray Bixby, and Daniel Booker came from the Midwest to Fox Island in 1889 and 1890, the Herculean task of removing giant trees and stumps would have discouraged most people; however, they not only cleared the land, they built a thriving community in the wilderness. Houses and barns were built, crops and orchards were planted and harvested, and civilization on the island expanded. In Sylvan, a church and school were built, as were a dock, store, post office, and a tourist lodge, which attracted more people to the community.

Once the land-clearing settlers were established, city dwellers came on steamships or launches to visit the new community. Some visitors were enamored enough to spend the summer months or buy available land on which to build summer or even permanent homes.

All the Fox Island settlements and industries were separated by pathways or logging skid roads, making the island totally dependent on water craft. When horse cart or buggy roads were extended and automobiles and trucks became more common, the inevitable next step of progress occurred around the start of World War I, when motor vehicles came to the island.

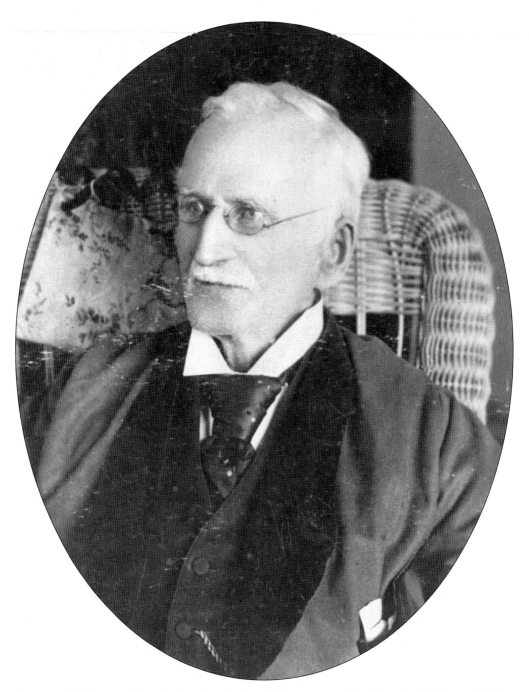

ANDREW J. MILLER. Sylvan's founder, Andrew Miller, came to Fox Island with his son Edwin in 1889 from Grinnell, Iowa. At the age of 69, when he made the move to the territory of Washington, he had the spirit of adventure and a vision to see beyond the struggle to clear the land of 500-year-old trees; he planted a community. His dream was totally realized by the time he died in 1898 in the Fox Island house he built in 1890. (Courtesy of the FIHS.)

PIONEER GIRL. Anne Carlson was born in 1895 on Fox Island. Her Swedish parents, Eric and Hilda Carlson, had recently moved to their farm on a cove to the west of Sylvan, near Towhead Island. Anne's birth was an important event for the island because she was the first white girl to be born here. Until she attended school, Swedish was the only language she knew. (Courtesy of the Nelson family.)

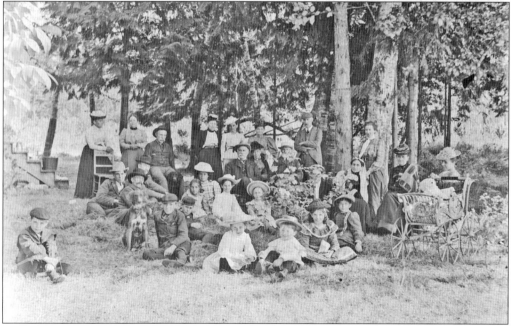

PICNIC AT KETNER'S POINT. From 1895 into the 1900s, picnics always were well attended throughout the summer months. The Ketners were known to always put on a good spread, but especially on the Fourth of July. (Courtesy of Harriet Ketner MacDuff.)

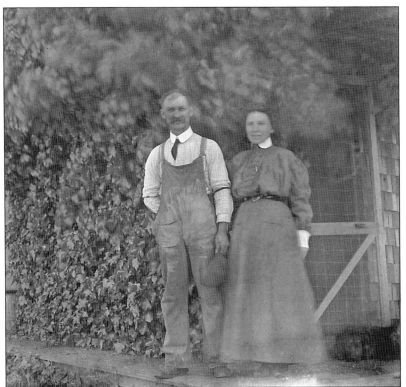

THE WHEELERS. Alvin and Grace Wheeler built a cottage to use in the summer as they lived in Tacoma the rest of the year. This property ended up being where the land store would be constructed in 1914. (Courtesy of the Wheeler family.)

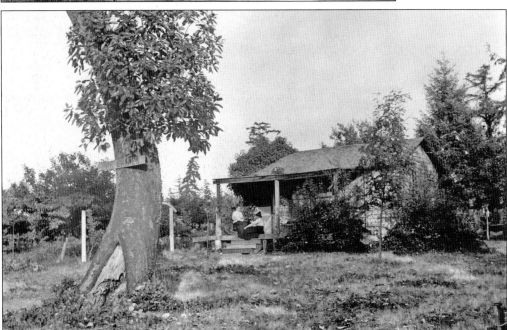

WHEELERS' COTTAGE. Before 1904, the Alvin Wheeler family from Tacoma built this summer cottage, which they named the Cranes (for the birds on the beach). After they sold this piece of property, they erected a three-story home two lots to the south and assigned the new dwelling the same name as the cottage. (Courtesy of the FIHS.)

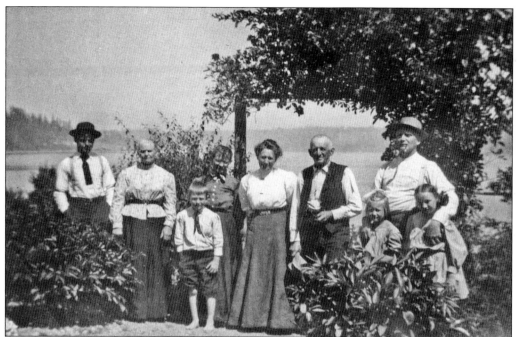

BB Bay Residents. In the 1910s, the residents around BB (Baker/Buck) Bay gather for a photograph. Hale Pass and the mouth of Wollochet Bay are behind them. From left to right are Rex Adams, Sue Baker, Eugene Buck, Nellie Adams, Alberta Buck, James Baker, Frances Buck Ward, George Buck, and Maude Adams. (Courtesy of the Buck family.)

The Bakers. James and Susan Baker were the first settlers on Boulder Beach in a cove on the east side of Ketner's Point. The bay in front of their house was named B Bay in their honor. (Courtesy of the Baker family.)

THE HERRICKS. Lucy and Stephen Herrick from Grinnell, Iowa, were among the first settlers of Sylvan and built a house at the southeastern corner of Sylvan (Echo) Bay in 1891. Stephen Herrick had owned a dry goods store in Iowa, and Lucy was an accomplished landscape artist. (Courtesy of the Fischer family.)

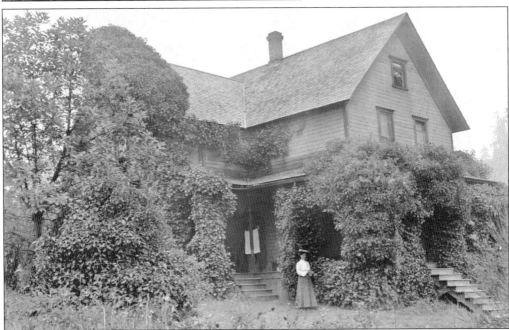

THE HERRICKS' HOME. Stephen Herrick was among the original Grinnell, Iowa, settlers in Sylvan-Glen, and he built this house in 1891 on the property where the first structure in the area had been built in 1879. Herrick and his descendants lived in this house until about 1950, when it was replaced. (Courtesy of the Dennis family.)

THE BIXBYS. Mary and Tilson Bixby, from Grinnell, Iowa, were among the first residents in Sylvan, building one of the first three homes of the community across the cove between what would become Ketner's Point and Miller's Point. (Courtesy of the Bixby family.)

THE RAY BIXBYS. Ray, baby Tilson, and Helen (Ketner) are pictured here in 1907, a year after Ray and Helen's marriage. Ray had come to Fox Island in 1889 as a 14-year-old to help his father, Tilson, clear the land, build their house, and plant an apple orchard. The Ray Bixby family built their home on the Bixbys' original property. (Courtesy of the Bixby family.)

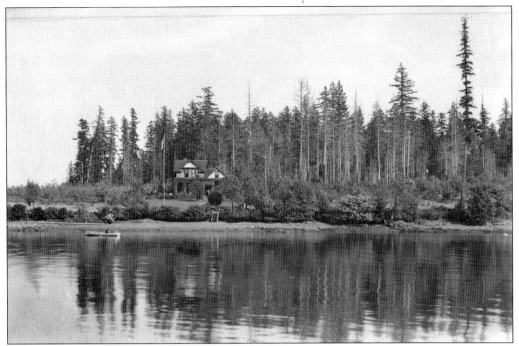

THE KETNERS. Richard and Harriet Ketner bought the point across the cove from the A. J. Millers in 1892 to be used as summer property. The land was cleared over the next two years, and in 1894, an existing home in the Macklin community was bought and moved to what the Ketners called Point Comfort. (Courtesy of the FIHS.)

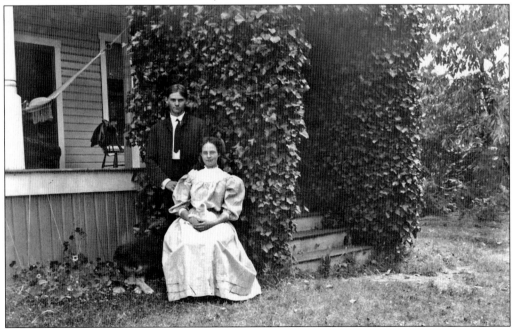

THE E. C. MILLERS. Edwin C. Miller and his wife, Myrtle Miller, pose in front of the first house in Sylvan, built in 1890 by Edwin, his father, A. J., and a carpenter. Myrtle bore her first child, Marion, in the house in 1900. (Courtesy of the FIHS.)

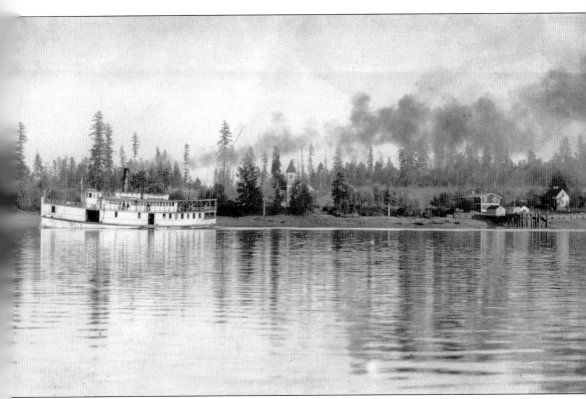

SYLVAN WITH STEAMER. This photograph taken from Grave (Hoska's) Island in the late 1910s shows the Sylvan waterfront from Miller's Point on the left to the church, the Sylvan Store, and the Cranes on the right. Two telephone poles are visible on the beach. (Courtesy of the FIHS.)

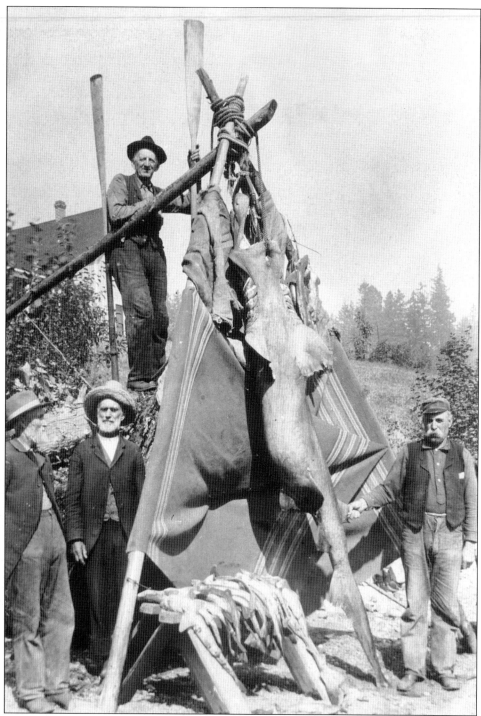

SHARK HUNTERS OF 1903. Some of the earliest settlers on Fox Island would occasionally fish for fertilizer (removing their livers) for their crops and orchards. Along with the catch of small spiny dogfish sharks, the intrepid fishermen snagged a large sixgill shark. From left to right are Tilson Bixby, Norman Buck, James Baker, and Dan Booker. (Courtesy of the FIHS.)

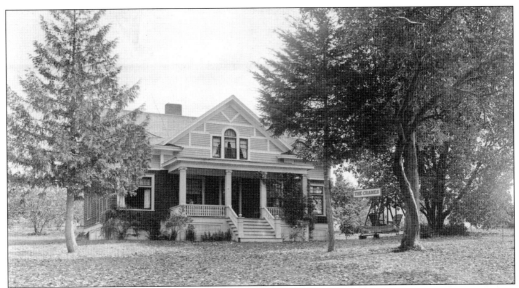

THE CRANES. Most of the houses of early Sylvanites had names. The Cranes was named for the birds that fished on Sylvan's shores. The W. C. Wheeler family owned three lots in Sylvan. They spent summers on Fox Island and wintered in Tacoma, where W. C. Wheeler was a partner in the Wheeler-Osgood Company that manufactured doors and other building material. (Courtesy of the FIHS.)

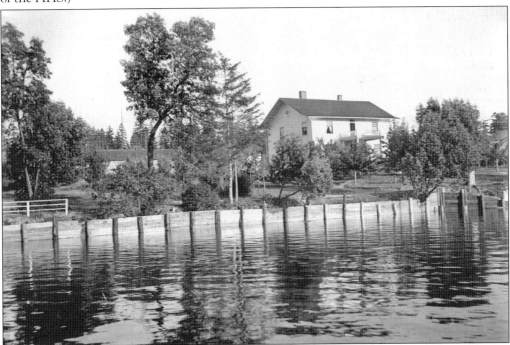

THE BULKHEAD. Beginning in 1906, a wooden bulkhead was under construction from the Sylvan Store to Packard's Cove (Shorewood). The project continued to 1909. The house seen in this photograph is the Laurels, built in 1904. The trees by the bulkhead are madronas, mistakenly thought to be laurels by the early Midwestern settlers, hence the "Laurels" tag given to the house. (Courtesy of the FIHS.)

THE LAURELS. Built by summer residents the A. N. Fitch family of Tacoma, this house was wired for electricity 27 years before it came to Fox Island. The house also had a sleeping porch that had tracks in the floor in order to move the beds inside the house for the winter. Another feature was a dumbwaiter from the basement to the kitchen. (Courtesy of the Powers family.)

THE MERRILLS. The Merrills, who were summer residents, built a cabin next to a lot owned by the Wheelers. In 1904, after the parsonage was built on the Wheeler lot, the Merrills sold the cabin to Mr. and Mrs. F. N. Leavens. This cabin remained virtually unchanged into the 1990s. (Courtesy of the FIHS.)

LITTLE CHURCH ON THE BAY. Attendance was small in the early days of the Fox Island Congregational Church, and some worshippers arrived by boat. As paths turned into roads, access to other parts of the island brought in more parishioners, and preachers were easier to entice to the sole church on Fox Island. (Courtesy of the FIHS.)

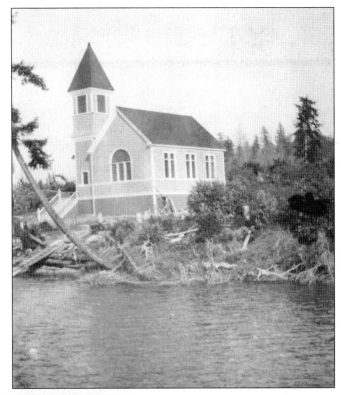

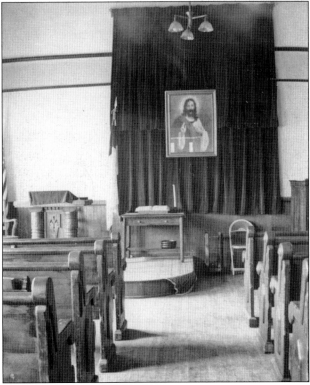

OLD INTERIOR OF CHURCH. Until the 1950s, the Fox Island Congregational Church looked like this. The pews faced east, and the entrance was at the northwest corner and through the bell tower room. It was decided to reverse the entire arrangement and build a new entrance at the east end of the church, giving a view of Tanglewood Island and the Olympic Mountains in the west. (Courtesy of the FIHS.)

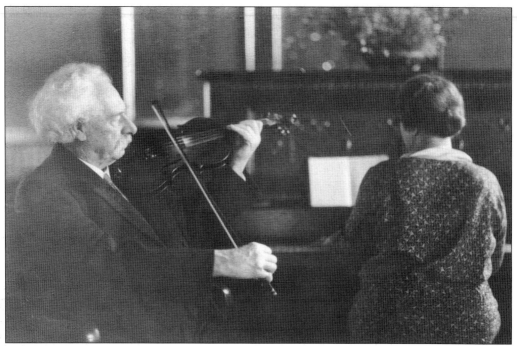

PASTOR WRIGLEY. Francis Wrigley was known as the "musical pastor" because he carried two violins wherever he went. Born and educated in England (Oxford), he served as pastor on Fox Island for 13 years in the 1910s, 1920s, and 1930s. (Courtesy of the Wrigley family.)

SUNDAY SCHOOL CLASS. This photograph was taken in the early 1910s. From left to right are Mae Bixby (teacher), Hedwig Hendrickson, Frances Buck, Fern Graham, Ida Hendrickson, Ethel Graham, and Hilda Carlson. (Courtesy of the FIHS.)

THE CEMETERY. When Sylvan's founder, Andrew J. Miller, died in 1898, he was buried on the Bixbys' property across from the prune dryer. Until 1911, those who died on Fox Island were buried there. Then the Hunter family, who owned property farther inland, donated two acres (1,000 grave plots) for the present graveyard. Those interred in the Bixby plots were moved to the two-acre site. (Courtesy of the Colvin family.)

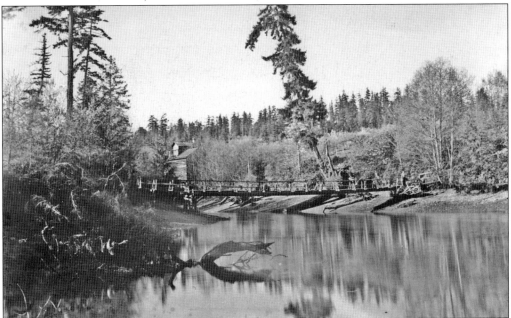

THE PRUNE DRYER AND LOG BRIDGE. The prune dryer at the end of the cove between Ketner's and Miller's Points was reached by rowboat or a tree bridge that connected the two points for those coming from the Ketner side. (Courtesy of the Bixby family.)

55

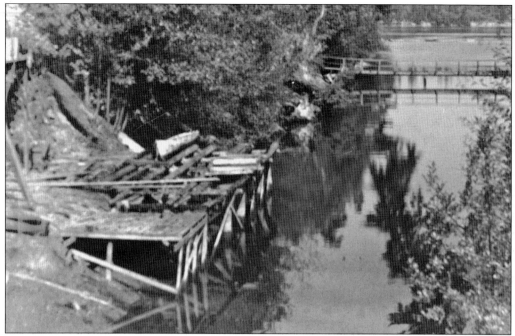

THE PRUNE DRYER. At the end of the cove between Miller's and Ketner's Points, the Sylvan Fruit and Vegetable Dehydration Company was built in 1896 in order to preserve Italian prunes that couldn't be sold fresh because of their overabundance. Other fruits and vegetables were also processed for several years. (Courtesy of the FIHS.)

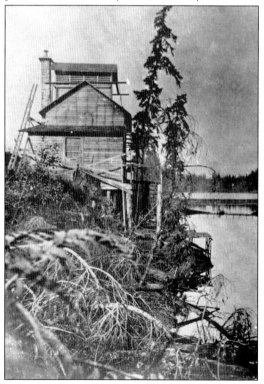

SOUTH SIDE OF THE PRUNE DRYER. Originally built for the Fox Island orchardists to dry the fresh prunes they couldn't sell, the prune dryer had so much fruit that it had to be expanded to accommodate the islanders and surrounding mainland growers. This was a profitable venture for several years. (Courtesy of the FIHS.)

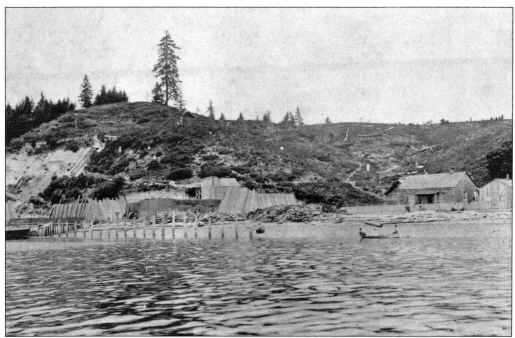

WATER VIEW OF THE BRICKYARD. The Fox Island Brick Manufacturing Company operated from 1884 until 1910 on the island's southeastern portion. At its peak, as many as 50 men were employed by the company. Besides brick, tile, sewer pipe, and other clay products were manufactured. (Courtesy of the FIHS.)

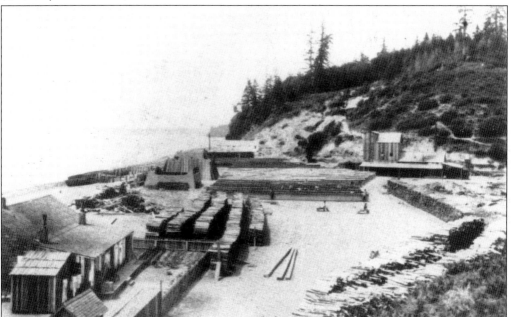

LAND VIEW OF THE BRICKYARD. In the midst of the brick-making industry community of the Brickyard were quarters for the workers, a mess hall, a post office, and a store. A school was also nearby. As there were three kilns for making the clay products, a large quantity of wood was required, evident from the wood piles in the bottom right of the picture. (Courtesy of the FIHS.)

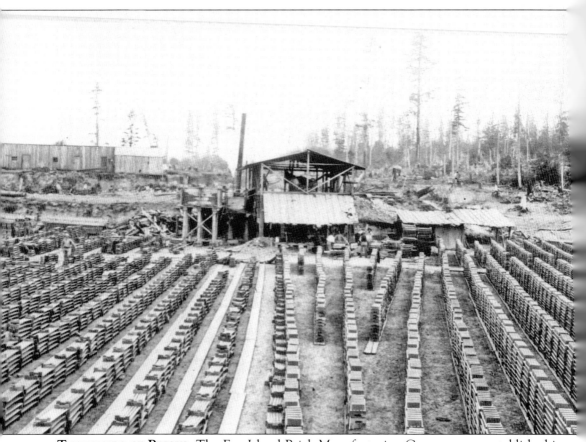

THOUSANDS OF BRICKS. The Fox Island Brick Manufacturing Company was established in 1884 on 435 acres located toward the southwest area of the island. The brickyard operated until 1910 when the clay deposits ran out. In its last years of operation, as many as 15,000 bricks were produced every week. (Courtesy of the FIHS.)

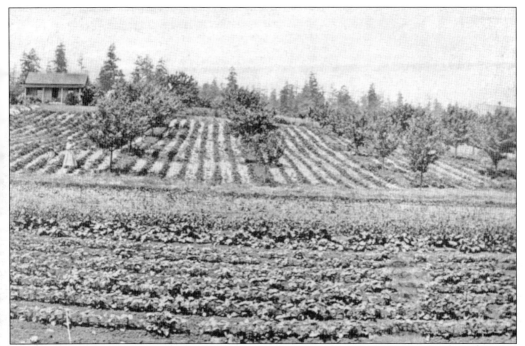

ISLAND FRUIT. By 1900, Fox Island farms were producing tons of fruit for export to the mainland and beyond. Strawberries were the first crop produced and were planted in the upstart orchards and vineyards until the trees and vines produced in quantity. (Courtesy of the FIHS.)

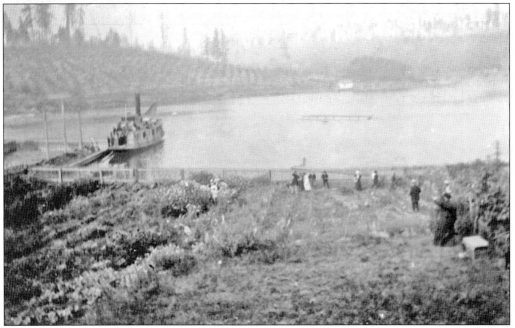

FRUIT AND PRODUCE PICKUP. Originally built in 1889 as a riverboat in Oregon, the *Typhoon I* was small enough to get close to the shoreline or small landings in order to pick up harvested crops as well as to deliver passengers and supplies to settlements that were somewhat isolated. (Courtesy of the FIHS.)

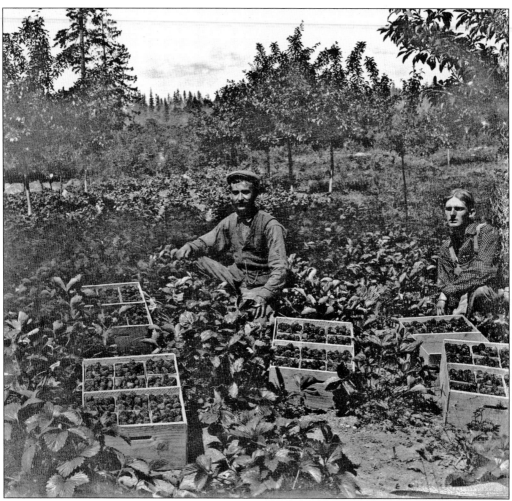

STRAWBERRY PICKERS. Fox Island strawberries were especially prized by Tacoma markets because of their size and the fact that they weren't bruised by being brought by horse cart. Early strawberry growers were the Bakers, Carlsons, and Bixbys. (Courtesy of Harriet Ketner MacDuff.)

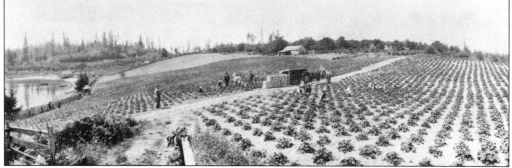

THE "STRAWBERRY KURGEN." Swedish settler Eric Carlson's 17 acres were mostly planted in strawberries. Because of this, he was known to local Swedes as "Strawberry Kurgen" or "Strawberry King." It had taken Carlson seven years to clear the land, and in 1895, he quit his job in Tacoma at the Ryan Smelter to become a Fox Island farmer. (Courtesy of the Nelson family.)

THE HENDRICKS FARM. As the forests were cleared inland on Fox Island, families like the Hendricks cleared stumps and brush in order to till the soil, plant a variety of crops, and develop productive farms. Most of the farms were self-sufficient. (Courtesy of the Hendricks family.)

THE BAKER FARM. Beginning in the early 1900s, James Baker was one of the premier strawberry farmers on Fox Island. The berries were loaded on steamships from a landing in front of his house on B (Baker) Bay and then taken into Commencement Bay in Tacoma. (Courtesy of the Baker family.)

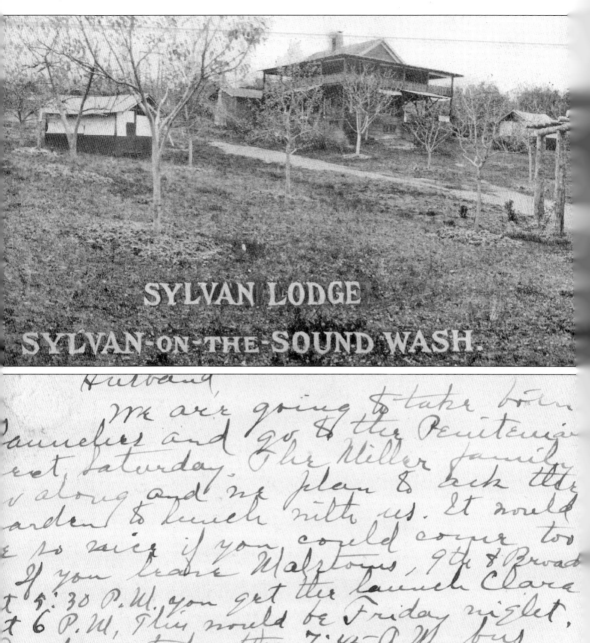

SYLVAN LODGE, 1915. Daniel and Emma Booker were the first couple to move to Sylvan-Glen in 1890, where they built a single-story house by 1891. A few years later, they added a second story to the house and sold it in 1906 to a Sylvan neighbor, Ed Wines. Wines had struck it rich in the 1898 Yukon gold rush, so he began adding on to the house in order to accommodate the steady influx of summer visitors to Fox Island. By 1915, the lodge had (on the first floor) six rooms, including a

public dining room and a kitchen. On the second floor were five bedrooms, four sleeping porches, and a bathroom. Behind the lodge were some bungalows for small families. On either side of the main building were tent cabins that had solid floors and roofs with canvas curtains on the side. On the beachfront were a boathouse and a long float. (Author's collection.)

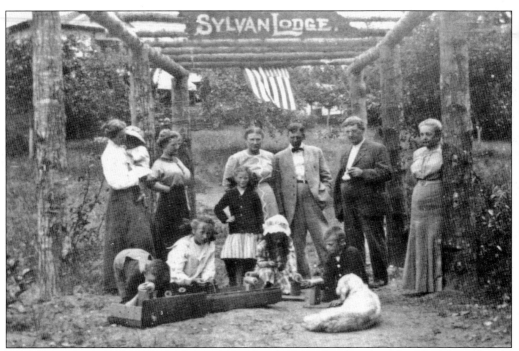

SYLVAN LODGE LODGERS. Starting in 1907, the Ed Wines family started building onto the old Booker home in order to accommodate the influx of visitors to Fox Island. On the far right is Milrose Wines with her husband, Ed, next to her. The child by the dog is Kenny Edgers, and the woman at the far left, holding the baby (Jane) is Cora Edgers. (Author's collection.)

MAKING BUTTER. During the years the Sylvan Lodge had a public dining room, it had as many as 50 diners per meal. Food preparation occupied many hours of work throughout the day in the summer months. Cows belonging to the Wineses, who owned the lodge, provided the dairy products consumed by the diners. (Author's collection.)

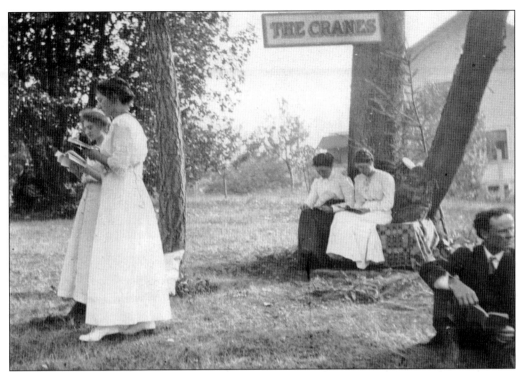

THE SHAKESPEARIAN READERS. William Shakespeare aficionados on Fox Island would take it upon themselves to assign parts from the bard's plays and give dramatic readings to whatever audience they could round up in the neighborhood of Sylvan in the community's early years. (Author's collection.)

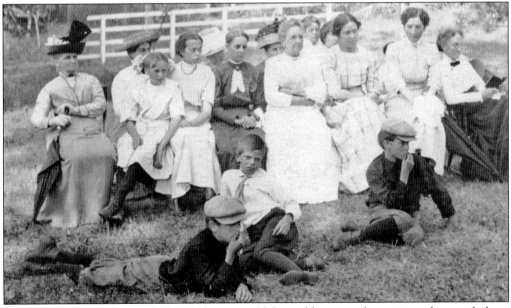

AUDIENCES AT THE LODGE. The Shakespeare Club would present dramatic readings to lodgers and neighbors after church on Sundays in the yard of the Sylvan Lodge in the years before roads and electricity. (Author's collection.)

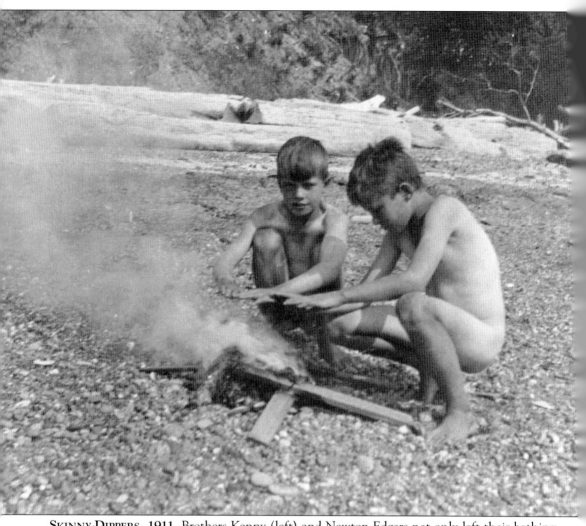

SKINNY-DIPPERS, 1911. Brothers Kenny (left) and Newton Edgers not only left their bathing suits but also their towels at the Sylvan Lodge when the urge to swim came upon them. There is always an abundant supply of driftwood on Fox Island's south side, so an impromptu fire was easy to get started. Unfortunately for the boys, their father didn't forget his camera. (Photograph by Dr. E. B. Edgers.)

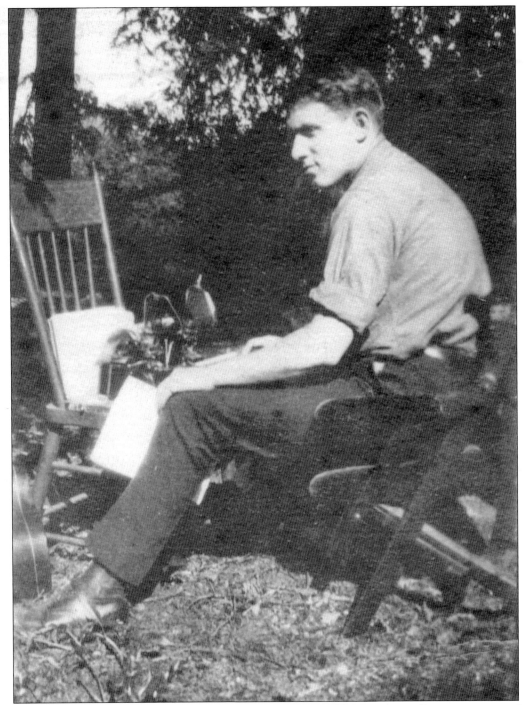

SPENCER TRACY, 1921. Before he got into movie acting, Tracy was a college roommate of summertime Sylvanite Kenny Edgers. The Tracy family "adopted" Kenny as their Washington son when he was attending school in Wisconsin. To repay the Tracy family's hospitality, the Edgers family invited Spencer to spend a month with them on Fox Island. This picture shows him working on a play during his island sojourn. (Author's collection.)

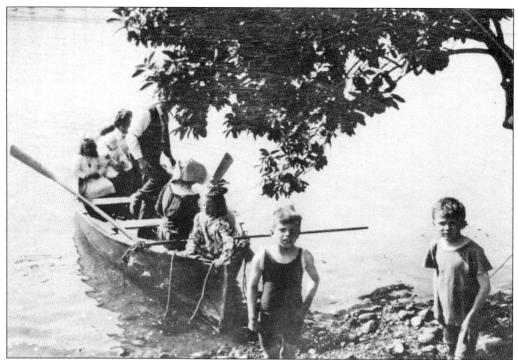

SUMMER COSTUMES. The attitude of what was appropriate summer dress varied widely from family to family in the Sylvan community. Visitors from the city didn't feel right unless they were fully draped or had the proper bathing attire. (Author's collection.)

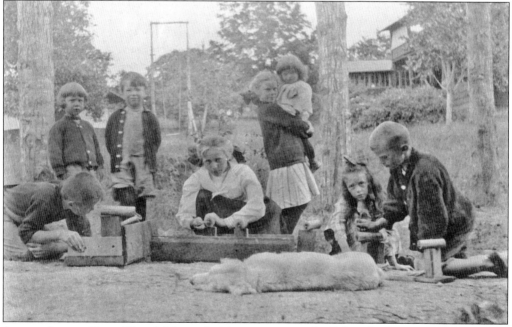

SYLVAN LODGE KIDS. The children of visitors staying at the Sylvan Lodge amused themselves in many creative ways. Here some older children are inventing some sort of device under the watchful eyes of their juniors and a bored dog. (Author's collection.)

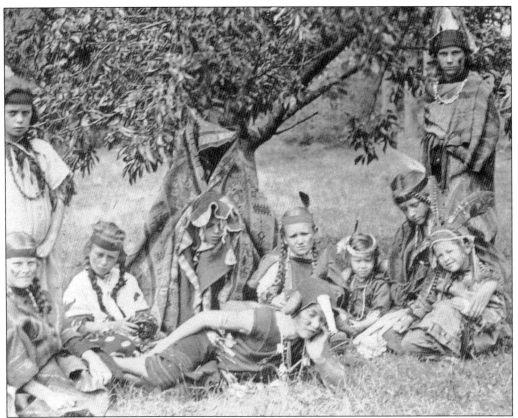

"TEN LITTLE INDIANS." During the summers from 1907 into the 1910s, a number of children were with their parents at the Sylvan Lodge. When they tired of water activities, they would sometimes put on impromptu plays or pageants. In this case, they have become Native Americans in full regalia, complete with a Persian-rug teepee. (Author's collection.)

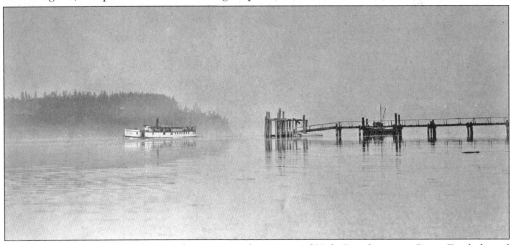

HALE PASS STEAMBOAT. A steamboat enters the waters of Hale Pass between Point Fosdick and the Fairmont Dock. The fog in the distance hides the Tacoma Narrows and the mainland of north Tacoma. In the late 1930s, the Tacoma Narrows Bridge would be visible from this location on Fox Island. (Courtesy of the Colvin family.)

PATHWAY TO FAIRMONT. The Fairmont Dock was just about halfway between the ferry landing and Hope (Cedrona Bay) on a path that ran all the way from Ketner's Point. After the roads for vehicles were built, the path became unused. (Courtesy of the Colvin family.)

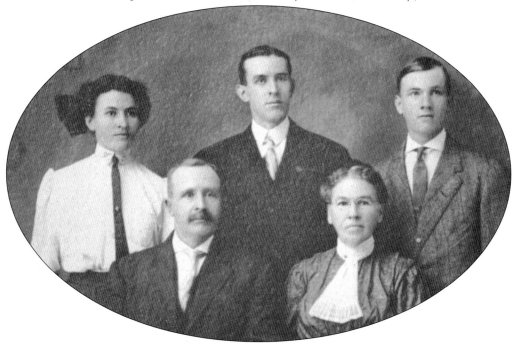

THE FAIRMONT COLVINS. The Colvin family lived about halfway between the ferry landing and Hope (Cedrona Bay) in an area known as Fairmont, where there was a dock. Their property was known as the Firs, where they built a home and raised chickens and fresh flowers and bulbs for export. From left to right are (seated) William E. Colvin and Emma L. Colvin; (standing) Grace, Guy B., and Robert E. (Courtesy of the Colvin family.)

LONE FIR FLOWER FARM. The Colvin family lived close to the Fairmont Dock at the northeast section of Fox Island. They raised flowers for the florist trade as well as bulbs for export. Their home was built before there were usable roads on the island. (Courtesy of the Colvin family.)

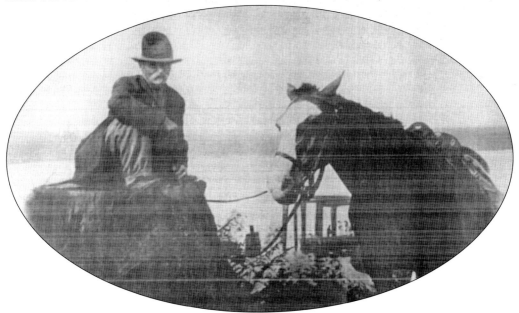

JOHN Q. LLOYD. In 1915, at the age of 68, John Q. Lloyd bought property on the island's south side, where he constructed a two-acre greenhouse in order to take advantage of the southern exposure. He successfully grew thousands of hothouse plants, which he sold to vegetable growers throughout the South Puget Sound. (Courtesy of the FIHS.)

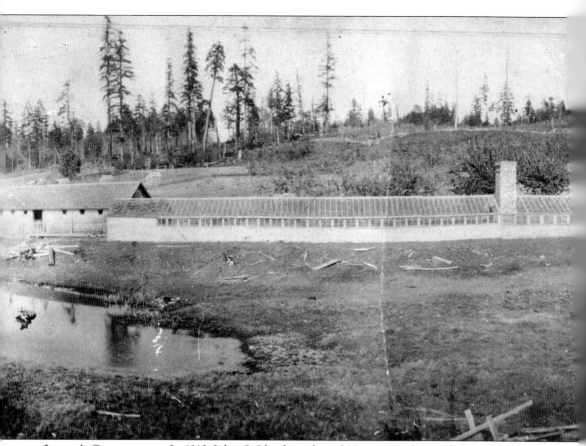

LLOYD'S GREENHOUSE. In 1913, John Q. Lloyd purchased 20 acres on the south side of the island, close to the Brickyard. He built this two-acre, wood-heated greenhouse where he raised tomatoes and other hothouse plants. Several employees worked in the greenhouse and delivered plants. Lloyd

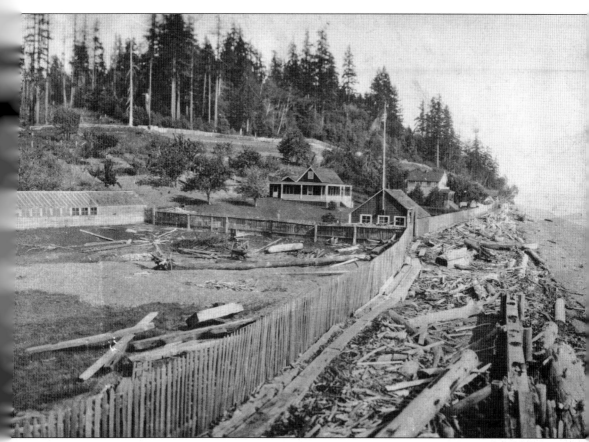
Greenhouse plants and produce, especially tomatoes, were highly prized by consumers throughout Pierce, Kitsap, and other counties. When he died in 1927, at the age of 80, the greenhouse was about half of the original size. (Courtesy of the FIHS.)

HOPE/CEDRONA BAY. This bay is toward the northeastern end of Fox Island, facing the Narrows. When the tide was out, the entrance became very shallow, and the larger steamers that carried the mail had to drop the mail on a raft anchored in Hale Pass. The postmaster would retrieve the mail and take it to the post office (1915–1932) up the hill of the bay. The name was changed to Cedrona (cedar and madrona) in 1921. (Courtesy of the FIHS.)

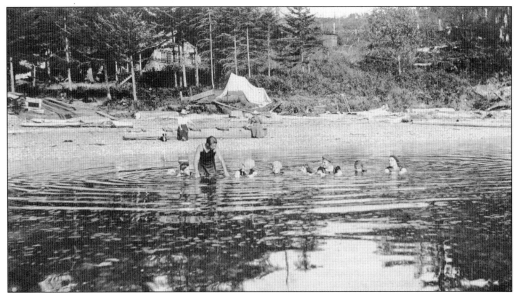

WARM WATER SWIMMERS. The only warm water for swimming in Puget Sound around Fox Island was in Smuggler's Cove or Hope (Cedrona Bay) on the north side, or on the south side of the island where the sun would warm the rocks. When the tide came in the afternoon, the water was tepid, full of dried seaweed and much like swimming in a pool of soup. (Courtesy of the FIHS.)

Three

THE FERRY YEARS

The first car to appear on Fox Island was in 1914 even though there weren't any roads for it to drive on. Permanent residents certainly didn't own motor vehicles, and some island children had never seen one in person, so the summer folks had to be the experimenters on the horse-cart tracks and wide paths.

The first ferry to the island was a two-deck, steam-powered vessel named the *Transit*, which was able to carry up to six Model T–sized vehicles on its top deck. The weather and tide had to be favorable to be able to load and unload its motorized cargo. Throughout its years of service as a ferry, the top-heavy craft never lost a car.

When the road system on Fox Island had improved to accommodate and attract more vehicles to the island, ferry-vessel design also improved, and the ferry design seen today became the standard. In the early 1920s, the *Transit* was replaced by the ferry *Fox Island*, a 90-by-33-foot diesel-powered vessel that could carry up to 35 Model T–sized cars. Originally named the *Wollochet*, the *Fox Island* was built in Gig Harbor by Skansie Brothers Shipbuilding.

In 1940, the ferry *City of Steilacoom* (an early settlement to the south of Day Island of Tacoma) replaced the *Fox Island* as the final ferry to serve the island. The new diesel ferry was similar to its predecessor in appearance and car capacity, but it was 20 feet longer. The 35-car capacity was applicable to automobiles of the 1920s; however, by the 1940s, the deckhands loading the ferry "would have to bounce the rear end's of car 16 and 17 to the ferry's side to fit in car 18." Capt. Maury Hunt was the ferry's premier skipper until August 1954 when the bridge from the mainland opened for business.

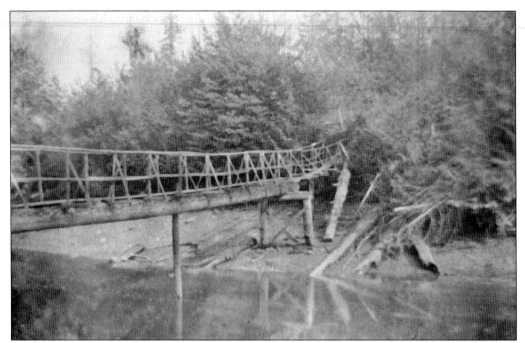

BRIDGE'S END. The Douglas fir tree that began as a bridge across the cove between Ketner's and Miller's Points in 1900 was at the end of its days in this 1930 photograph. Hundreds of feet had walked its length during its 40-year lifespan. (Courtesy of the FIHS.)

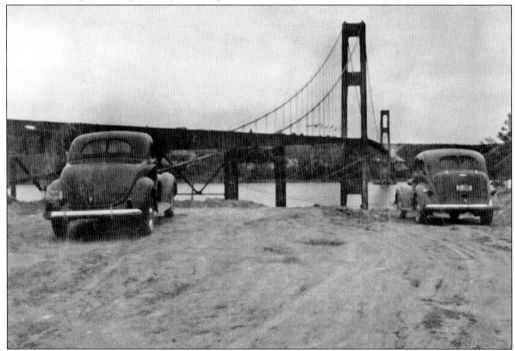

THE 1940 BRIDGE. Unlike the 40-year lifespan of the Douglas fir log bridge across the Ketner-Miller Cove, the first Tacoma Narrows Bridge only lasted a matter of months when it connected Tacoma to the Olympic Peninsula. (Courtesy of the FIHS.)

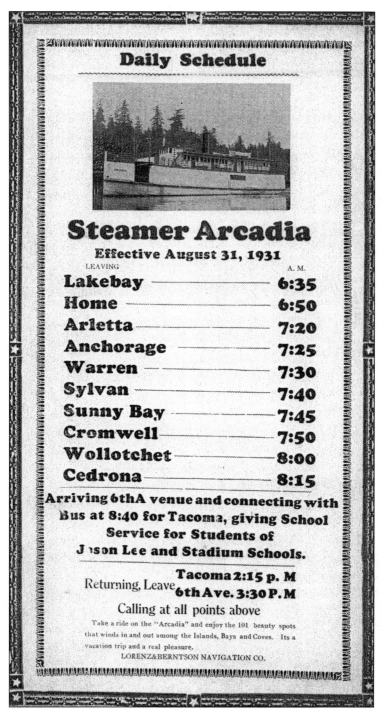

ARCADIA SCHEDULE, 1931. Built in Tacoma, this 101-by-17-foot vessel was built for speed, and in its early years of operation catered to passengers as well as freight, making as many as 15 landings a day. Fox Island high school students would take the boat to Tacoma, where they caught a bus at Sixth Avenue to Stadium High School, which overlooked Commencement Bay. (Courtesy of the FIHS.)

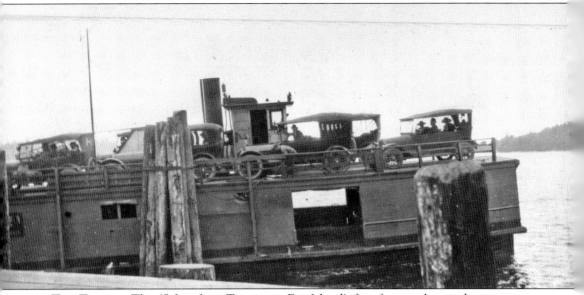

THE TRANSIT. The 65-foot ferry *Transit* was Fox Island's first ferry and started carrying cars on its upper deck to the island in 1914. At that time, there were only about two miles of drivable roads, so its six-car capacity was seldom achieved until the 1920s. Although the vessel looked top heavy and unstable, no cars were ever lost. The ferry ended up burning in 1945. (Courtesy of the FIHS.)

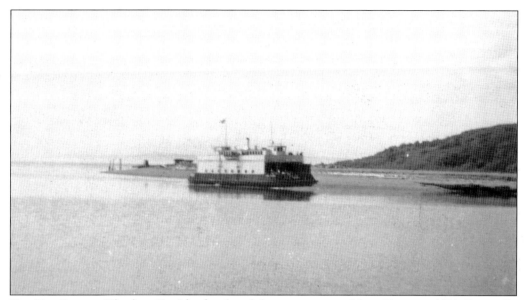

THE FOX ISLAND. The ferry *Fox Island* replaced the steam-powered ferry *Transit* in 1921. Originally named the *Wollochet*, the 90-by-33-foot diesel ferry was built in Gig Harbor and ran from Day Island to Fox Island until 1940. Finally, it was on the Bremerton–to–Port Orchard route. This picture was taken near Keystone when it was on the latter route. (Courtesy of the FIHS.)

FOX ISLAND TRAFFIC. The early roads on Fox Island didn't connect one end of the island to the other and their quality wasn't assured, especially in the winter. The expression, "You can't get there from here," may well have originated on Fox Island. Ferry service may have begun in 1914, but any trips on the island's so-called roads were quite short. (Courtesy of the FIHS.)

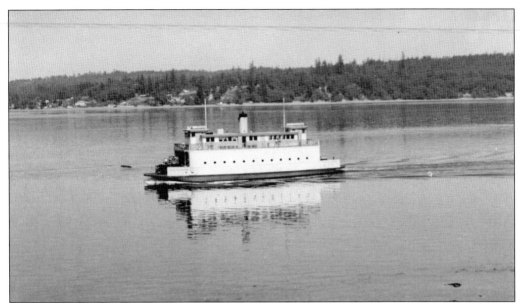

THE CITY OF STEILACOOM. This 110-foot ferry was the last to Fox Island, serving from 1940 to 1953. Built to carry 35 Model A–sized cars, it could only accommodate eighteen 1940-sized cars. This vessel only had a propeller at one end, so the ferry had to be turned around after loading in Tacoma and backed into the Fox Island ferry dock upon arriving there. The last crew members were as follows: captains Maurice Hunt, Morris Carlson, and Lincoln West; pursers Ed Erickson, Cecil Fassett, and Stanley Wilson; engineers Cecil Schy, Carol Langtree, and Joe Twogood; deckhands Roy Beals, Leslie Ramsdell, Ward Hunt, and Carl Sanstad; and night watchman Fred Turver. (Courtesy of the FIHS.)

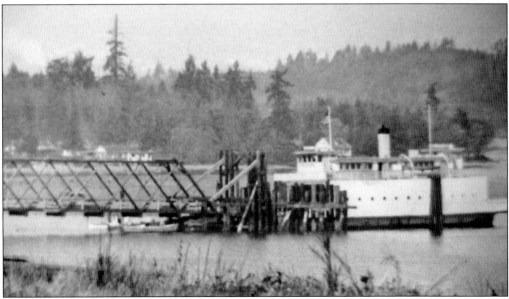

THE FOX ISLAND FERRY. The *City of Steilacoom* served as the ferry to Fox Island from 1940 until the bridge opened in August 1954. The ferry's route was from Titlow Beach in Tacoma to the Fox Island ferry landing. After the last run from the Tacoma side at 7:00 p.m., the vessel would tie up at Fox Island overnight with a night watchman onboard. (Courtesy of the Hunt family.)

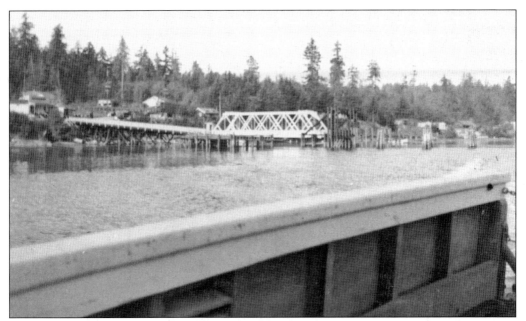

FERRY-EYE VIEW. A complete view of the Fox Island ferry landing is visible in this view from the car deck of the ferry, the *City of Steilacoom*, as it approaches the island after a 40-minute crossing from Titlow Beach of Tacoma. (Courtesy of the FIHS.)

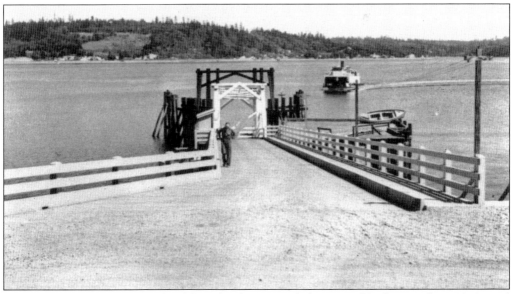

FERRY LANDING. The Fox Island ferry landing served the *City of Steilacoom* from 1940 until 1953 as its only ferry. The entrance to Wollochet Bay is visible behind the ferry on one of its eight daily round-trips from the island to Tacoma at Titlow Beach and Sixth Avenue. (Courtesy of the FIHS.)

Ferry Landing Parking. Bob Edgers and his mother, Lois, load the rumble seat of Bob's 1930 Model A Ford. The Fox Island Trading Company store across the road from the ferry dock and landing was the object of this trip in the car because the Model A was strictly an "Island car" that was unable to travel on the mainland at speeds over 35 miles per hour. The vehicle never loaded onto the ferry, seen in the background. (Author's collection.)

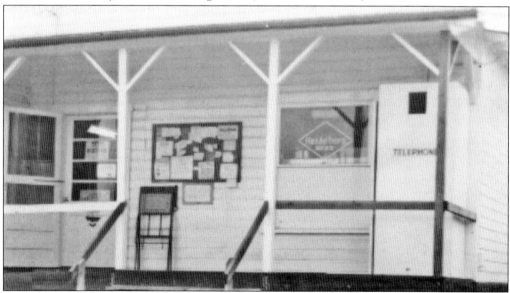

The Fox Island Phone. From 1910 until 1931, there was a single phone, which was at the Sylvan Store. A ship's anchor severed the phone line, so the island had no phone again until 1953. Once again, Fox Island had a single pay phone, this time at the Fox Island Trading Company at the ferry landing. On weekends, the phone was so busy that the coin box would fill up and the phone was inoperative until the coin box was emptied on Monday. In 1956, there were 75 subscribers. (Courtesy of the Walker family.)

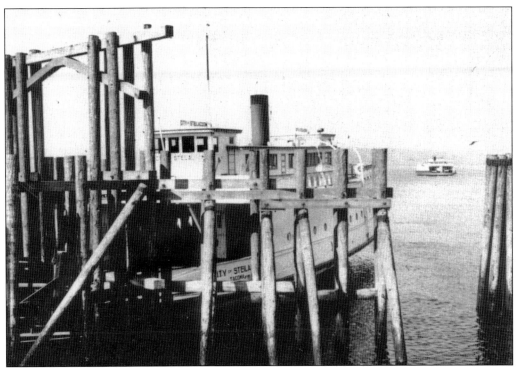

SIXTH AVENUE FERRY LANDING. The ferry landing on the Tacoma side was located at the far west end of Sixth Avenue at Titlow Beach. It served both the Fox Island and Point Fosdick ferries. The *City of Steilacoom* is docked on the left, and the mainland ferry is seen in the distance between the pilings. (Courtesy of the FIHS.)

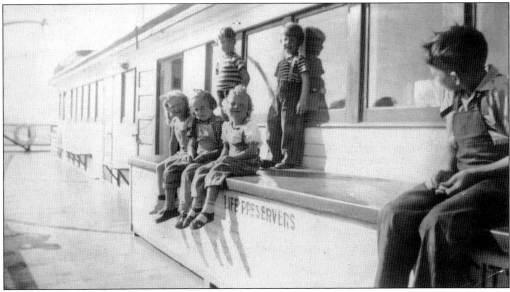

YOUNG FERRY RIDERS. The ferry *City of Steilacoom* had two separated passenger cabins: a larger non-smoking cabin for women and children and another for men and smokers. On nice days, the children escaped their regular confines to stretch their legs or visit with their friends on the outside deck. (Courtesy of the Powers family.)

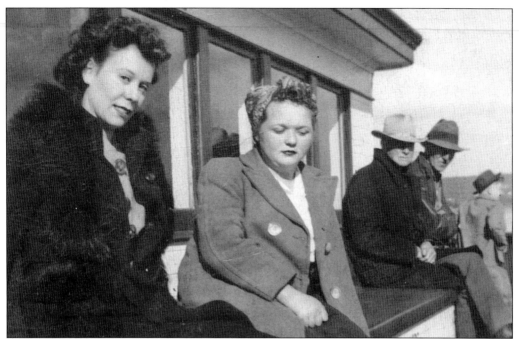

FERRY PASSENGERS. When the sun was out, passengers would often sit on the life preserver lockers of the *City of Steilacoom* in order to get a dose of sun. There were two indoor waiting rooms—a large one for women and children that was smoke free and a smaller one for men or smokers that usually had a card game going on the late afternoon runs. (Courtesy of the Powers family.)

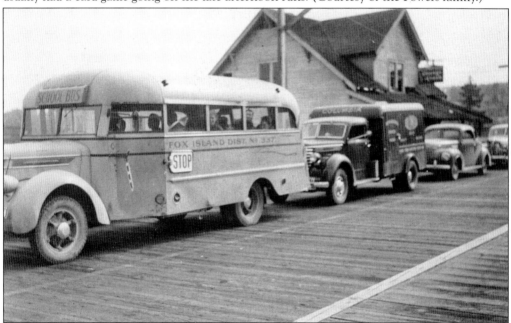

THE ISLAND BUS. The Fox Island schools had a school bus starting in the early 1920s with a Model T truck. Rarely did the school bus ever leave the island, except on the occasion of a field trip to a museum or other cultural destination. Here it sits in line at the ferry landing at Titlow Beach. (Courtesy of the FIHS.)

Capt. Floyd Hunt. Born in 1875, Floyd Hunt was a pioneer boatbuilder as well as a captain of steamers and ferries that operated in South Puget Sound. His son Maury lived on Fox Island and was the last captain of the ferry *City of Steilacoom*. (Courtesy of the Hunt family.)

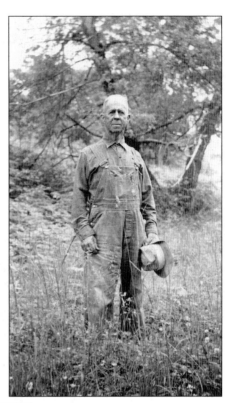

Capt. Maury Hunt. A descendant from the shipbuilding Hunt brothers of Gig Harbor, Captain Hunt moved to Fox Island after he leased, then skippered, the last ferry to Fox Island, the *City of Steilacoom*. He piloted the ferry eight trips and 13 hours a day for the better part of 14 years. He was held in high esteem by all Fox Islanders and retired to the island in 1954. (Courtesy of the Hunt family.)

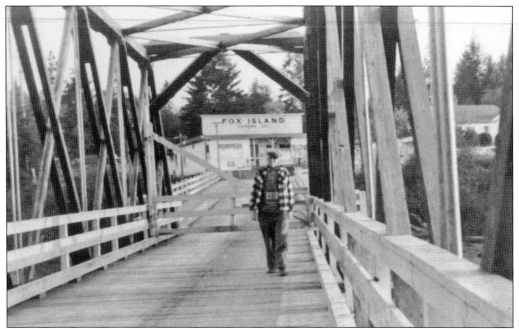

The Ferry's Purser. Ed Erickson was a man who wore many hats. Besides being the purser for the *City of Steilacoom*, he was Master of the Grange, owner of the Sylvan Lodge, Camp TaHaDoWa's building foreman, and a building contractor. (Courtesy of the Erickson family.)

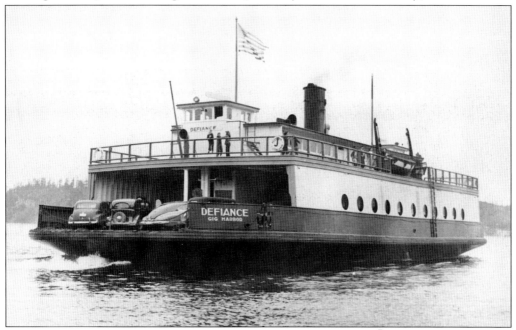

The Defiance. This 157-by-49-foot wooden ferry was built in Gig Harbor by Skansie Brothers Shipbuilding in 1927 to serve from Point Defiance in Tacoma. For a while, she served on the run from Titlow Beach in Tacoma to Point Fosdick across the Tacoma Narrows. The ferry *Fox Island* was serving the island from the same ferry landing at the time this picture was taken. (Courtesy of the FIHS.)

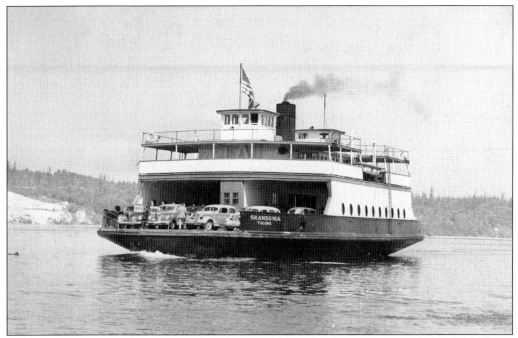

THE SKANSONIA. Another wooden ferry built in Gig Harbor by Skansie Brothers Shipbuilding was this 165-by-50-foot vessel. She was built in 1929 and powered by two diesel engines. Today the ferry is moored on Lake Union and used for weddings and banquets. (Courtesy of the FIHS.)

FERRY TICKET. Although this is a ticket from another nearby ferry, the fares were similar for most ferries in the South Puget Sound. A round-trip for a car was 75¢, passengers were 35¢, and children were 10¢. (Courtesy of the FIHS.)

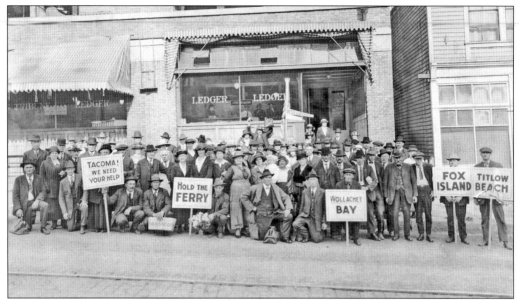

FERRY DEMONSTRATORS. During the 1930s, there was talk of changing or eliminating ferry runs from Tacoma to the Gig Harbor side of the Olympic Peninsula, Vashon Island, and Fox Island. Concerned citizens lined up in front of the newspaper (Tacoma) *Ledger* with their picket signs in order to get their picture in the newspaper and draw attention to their concern. (Courtesy of the FIHS.)

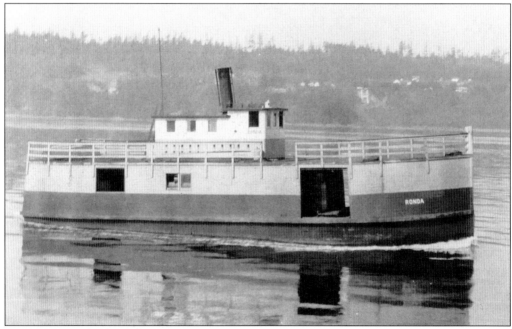

THE RONDA. The *Ronda* became part of the Mosquito Fleet in 1923. She was built as a 60-foot wide-hulled freighter in Gig Harbor for the Wight brothers of Fox Island. The *Ronda* originally had a 50-horsepower steam engine, but after a 1924 fire in the engine room, the boiler was dumped in Sylvan Bay to be used as a float anchor. The little freighter continued operating with a diesel engine until 1999, when it burned by Shorewood. (Courtesy of the FIHS.)

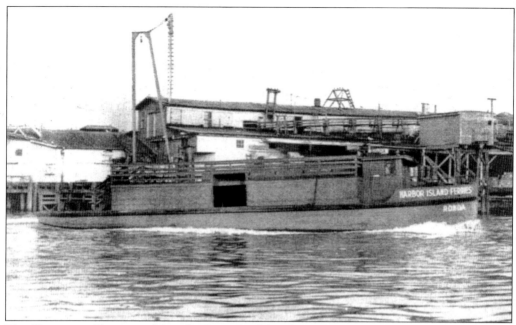

THE RONDA IN TACOMA. After the Fox Island freighter was sold to skipper Tom Torgeson of Fox Island, he operated it on other runs in South Puget Sound, like Anderson Island. (Courtesy of the FIHS.)

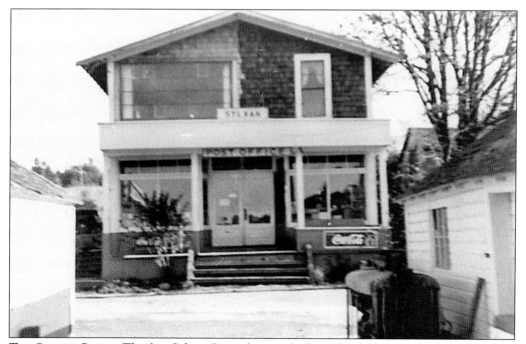

THE SYLVAN STORE. The first Sylvan Store that was built on the dock is on the right. The store and post office moved to the two-story structure in 1914, or about 30 years prior to this photograph. (Courtesy of the FIHS.)

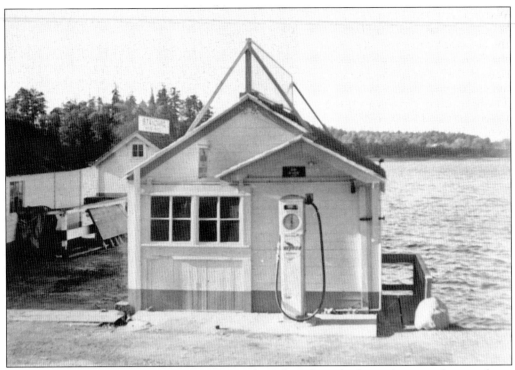

SYLVAN STORE GAS PUMP. The gas station at the Sylvan Store had petroleum products and two outhouses (on the right) over the beach in the building behind the pump. The building on the left, used for storage, is the original Sylvan Store and Post Office. This photograph was taken in the 1940s. (Courtesy of the FIHS.)

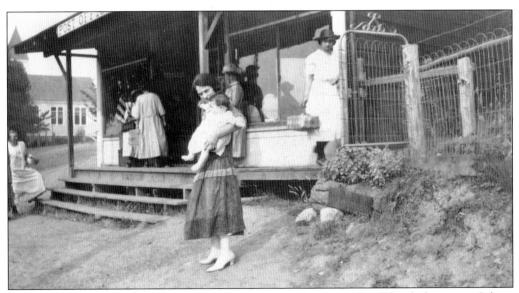

SYLVAN STORE IN THE 1930s. Although there were two stores on Fox Island, the one in Sylvan housed Fox Island's post office and frozen food lockers. The Sylvan Store only had one gas pump. The ladies in this picture are shopping for food or visiting with neighbors after retrieving their mail. (Courtesy of the Wight family.)

WAITING FOR THE MAIL. This photograph was taken in 1949, the last year for the post office in the Sylvan general store. Obvious signs of the building's deterioration are visible after 35 years of use. The ladies on the steps are Lois Edgers (left) and Marion Fall from California. The man on the porch is Jack "Pa" Bloom, who owned the store from 1932 to 1945. (Author's collection.)

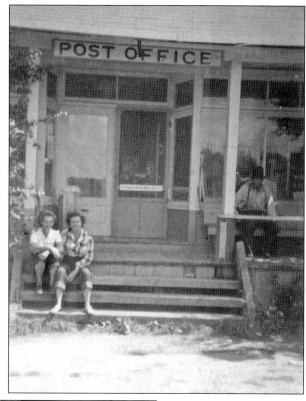

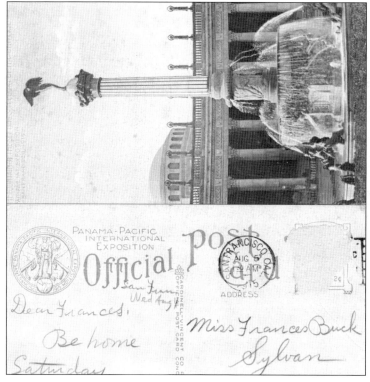

A 1915 POSTCARD. This postcard of the Panama-Pacific International Exposition sent from San Francisco during the summer of 1915 had no problem reaching the Bucks at the Sylvan Post Office. It wasn't until 40 years later that Sylvan was replaced by Fox Island as an address. (Courtesy of the Buck family.)

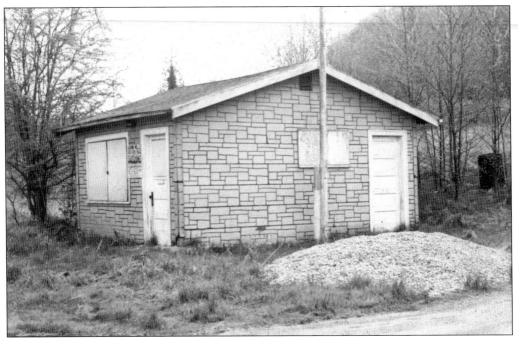

THE BULKHEAD POST OFFICE. In 1949, this building replaced the Sylvan Store's post office. Clyde Bowyer, who lived nearby, became the postmaster for the next six years. Dorothy Eldridge was the postmaster here until 1964, when this building was closed and the post office moved to its location near Amen Corner. (Courtesy of the Bowyer family.)

NORTH SIDE OF THE CHURCH. Until 1954, this was the view down the road from Edgers' Point. In 1955, a small guesthouse and garage was built in front of the telephone pole, which would change the landscape that had existed since 1900, when the church was built. The Sylvan Store, built in 1914, is visible beyond the church. (Author's collection.)

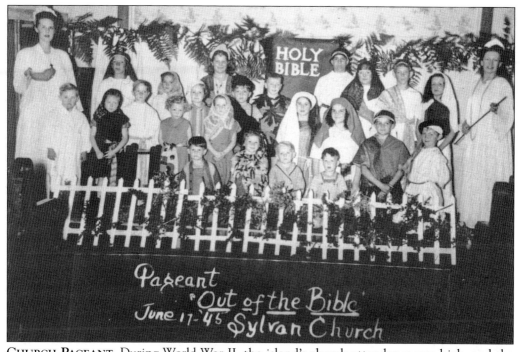

CHURCH PAGEANT. During World War II, the island's church attendance was high, and the women and children who attended services were very active in church-related activities, such as this summertime pageant. (Courtesy of the FIHS.)

REMODELED CHURCH. Sometime in the 1950s, Ed Erickson and crew covered the steeple with aluminum sheeting. The interior of the sanctuary was also completely remodeled. On the beach, a retaining wall was built in 1960, and a basement with toilets, furnace, and a kitchen were constructed. The Congregational denomination was changed to the United Church of Christ in 1961. (Courtesy of the FIHS.)

THE LODGE IN THE 1930S. The Sylvan Lodge was originally built in 1890 by the Daniel Bookers as a single-story house; the upper story was built in 1901 and sold in 1906 to the Wineses and then in 1930 to the Ed Ericksons. This is the Sylvan Lodge as it appears in the 1930s. (Courtesy of the Erickson family.)

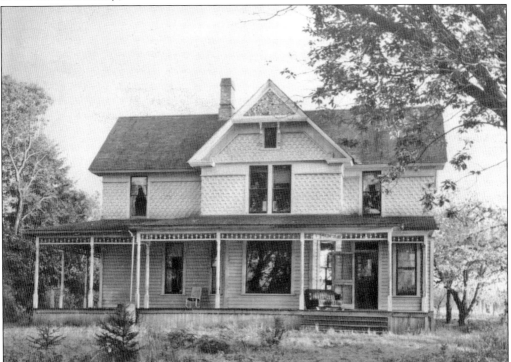

THE MILLER HOUSE. In 1890, when A. J. and E. C. Miller were building this house, there were no trees to be seen. Fifty years later, there are mature chestnuts (on left), madronas (top right), and bing cherries (right, next to the house) filling the once empty space. (Author's collection.)

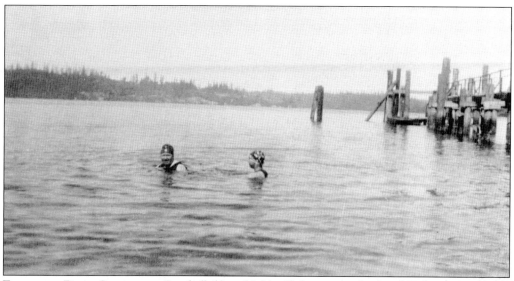

FAIRMONT DOCK SWIMMERS. Sarah (left) and Libby Holt swim in the frigid Hale Pass waters on the north side of Fox Island. Beyond the Fairmont Dock to their right is the Tacoma side of the Narrows. (Courtesy of the Holt family.)

CAMP TaHaDoWa. The camp for boys was open in the summer of 1947 on 18-acre Tanglewood Island. Before it opened, Dr. A. L. Schultz chose the name TaHaDoWa, a Puyallup tribal word for "Welcome in." As Dr. Schultz explained in a *Seattle Times* newspaper article, "Grave Island in olden times was a burial ground for the Nisqually Indians, but I couldn't find a Nisqually word to fit the subject." (Author's collection.)

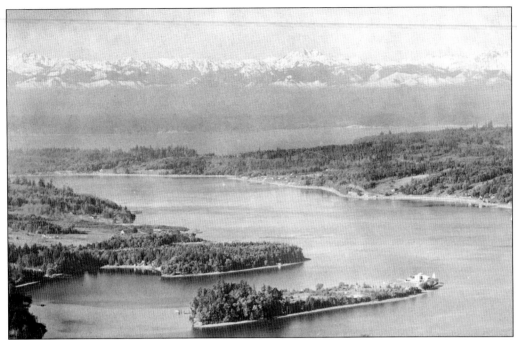

WEST HALE PASS. In this 1952 aerial photograph, there is no sign that a year later a bridge would be under construction just 400 yards beyond the lighthouse on Tanglewood Island. The Olympic Mountains are visible in the distance. (Courtesy of the Schultz family.)

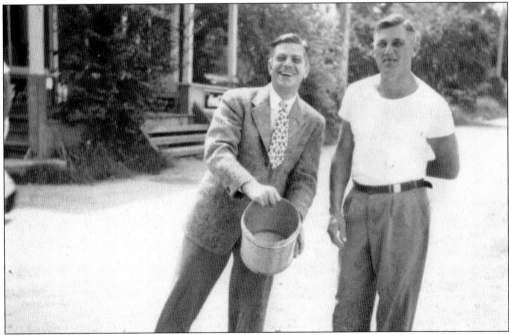

DR. EDGERS AND DR. SCHULTZ. Dr. Kenneth Edgers (left) is the owner of the original A. J. Miller house and property. Dr. A. L. "Dick" Schultz (right) is the owner of Grave Island and builder of Camp TaHaDoWa on the little island's north end. This 1948 picture shows the doctors on the road in front of the Sylvan Store. (Author's collection.)

THE CAMP'S POOL. The last part of Camp TaHaDoWa's construction in 1946 was the building of the 25-by-75-foot saltwater swimming pool. The pool was filled through an inlet pipe with saltwater from a high tide and was heated with sunlight. Thousands of boys swam in this pool during its 20-year lifespan. (Courtesy of the Schultz family.)

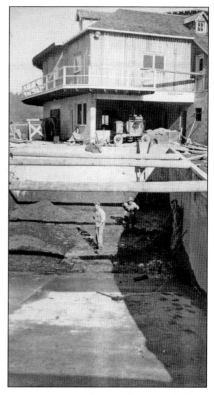

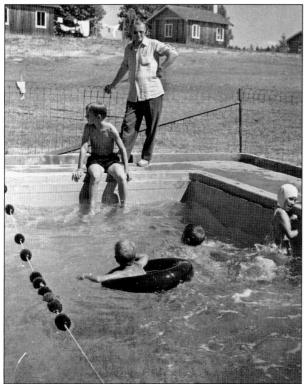

CAMP POOL AND CABINS. On visitor weekends, Camp TaHaDoWa campers' families were able to use the saltwater pool, but during the week, it was used strictly for teaching swimming and water competition. In the background, two of the eight-man cabins can be seen. (Courtesy of the Schultz family.)

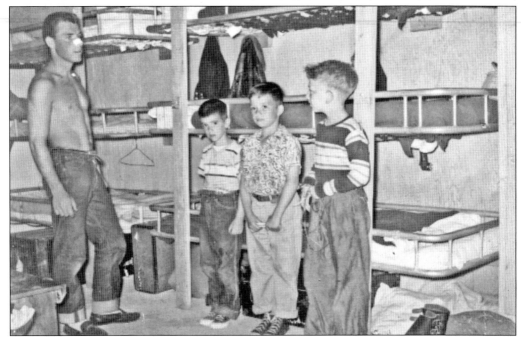

TaHaDoWa Campers. Eight boys, including a junior and senior counselor, lived in each log cabin that was their summer residence for six to eight weeks. Three campers stand in front of their bunks as a counselor checks them out for their daily activity schedule. (Courtesy of the Schultz family.)

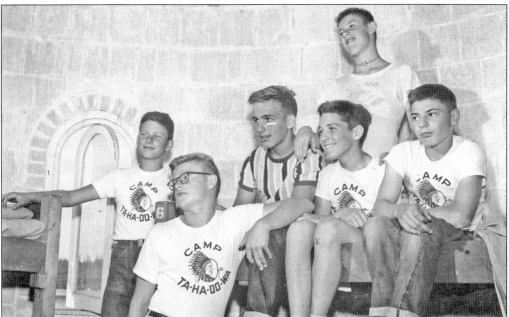

Campers in Lighthouse. Some "seasoned" campers had to bunk in the lighthouse of Camp TaHaDoWa when the cabins were full. Campers are, from left to right, Kimo Streeter, Don Shotwell, Jake Little, Gill Richard, Tom Tonelson (behind), and George Swyzle. (Courtesy of the Schultz family.)

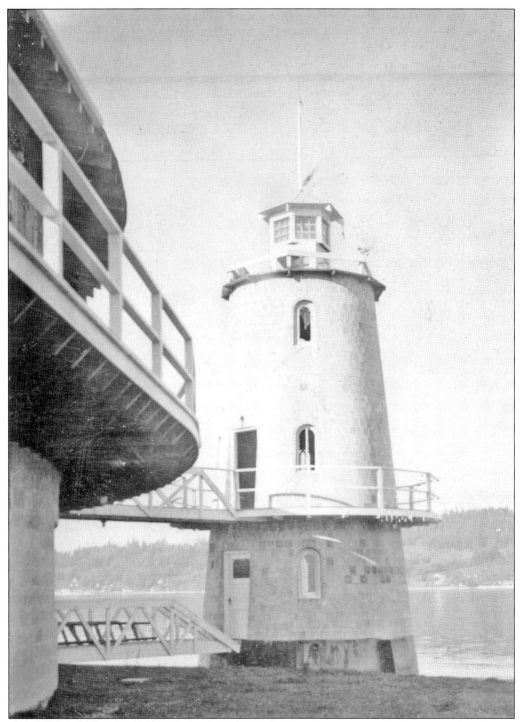

THE TANGLEWOOD ISLAND LIGHTHOUSE. In 1947, this structure was the first round lighthouse to be built in the United States in 85 years. It was constructed with concrete blocks; 45 feet tall and 18 feet at its base, tapering to 15 feet at its top. The light at its peak was for decoration rather than navigation. (Courtesy of the Schultz family.)

WILLITS BROTHERS CANOES. Part of Camp TaHaDoWa's training involved learning how to paddle wooden canoes made by the Willits brothers of Day Island in Tacoma. The camp owned 10 of these double-planked cedar vessels. Advanced training involved righting a swamped canoe. In this case, a counselor shows off balancing a canoe without turning it over. (Courtesy of the Schultz family.)

COLD WATER SWIMMERS. In the 1920s, the Moser and Colvin families, whose children are pictured, lived toward the northeast end of Fox Island by the Fairmont Dock, across Hale Pass from Point Fosdick. The water in this area has a swift tidal current, making the water chilly enough to cause swimmers to prefer to take a trip in a boat rather than a dip in Puget Sound. (Courtesy of the Colvin family.)

The Wight Kids. The Arthur Wight family owned and operated the Sylvan Store and Post Office from 1919 to 1936. On the south side of the store was a maple tree, just the right size for climbing. The children are Mary, Chauncey, and their cousins John and Billy. (Courtesy of the Wight family.)

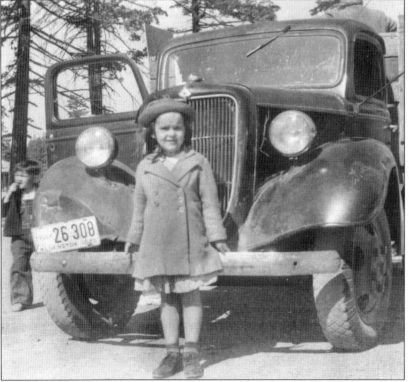

The Ramsdells' Truck. Tom and Dolly Ramsdell stand by their dad's (Ross) truck, which was used for hauling in Tacoma and Fox Island. The Ramsdells lived on the southeast corner of Amen Corner and sold ice that was delivered around the island. (Courtesy of the Ramsdell family.)

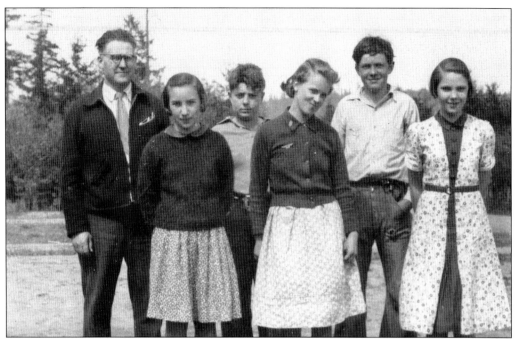

CLASS OF 1939. The eighth-grade graduates of the five-year-old Fox Island School were taught by Fox Island pioneer descendant Ray Bixby. The students next to Bixby are, from left to right, Grace Peterson, James Day, Marie Botnen, Bill Ramsdell, and Mary Wight. (Courtesy of the FIHS.)

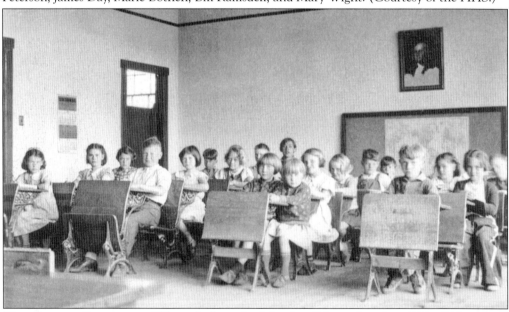

NEW SCHOOL CLASSROOM. When the Lincoln School at Sylvan closed in 1928, all Fox Island schoolchildren attended the Benbow School near Hope (Cedrona Bay). The Fox Island School was built in the middle of the island in 1934 by the Works Progress Administration. It had two rooms for classes, a lunchroom-auditorium, a kitchen, lavatories, and a basement that could be used on rainy days. Closed in 1961, the building serves as the Nichols Community Center. (Courtesy of the FIHS.)

EDGERS' POINT. The name of this point of land extending into Hale Pass of Puget Sound took on the name of the owner of the property. Beginning in 1890, it was known as Miller's Point, then in the 1920s until 1944, it became Cook Point. After that, the name was changed to Edgers' Point. The only thing that remained constant over the years was the house. (Author's collection.)

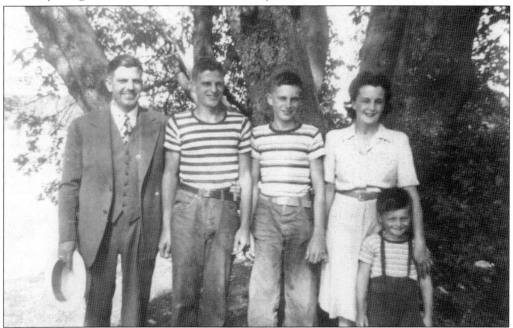

THE EDGERS FAMILY, 1944. Miller's/Cook Point changed to Edgers' Point in 1944. Standing in front of giant madronas on their new property are, from left to right, Dr. Kenneth, Bart, Bob, Lois, and Don Edgers. (Author's collection.)

NEW FAMILY IN THE CHICKEN COOP. In 1951, Bart, baby Debbie, and Nancy Edgers are seen in front of the recently remodeled Millers' chicken coop, built in 1889. The chicken coop was used as a bunkhouse for the builders of the first houses constructed in 1890–1891 in Sylvan-Glen. Very few chickens actually ever occupied the building, and the Edgerses used it as a summer house until 1969. (Author's collection.)

WAITING FOR A ROWER, 1946. In the cove between Ketner's and Edgers' Point lie three boats and a boy in a life jacket waiting for the photographer to take a picture. In another minute, the rowboat will head to the old prune dryer or the Sylvan Dock to check on the fishing prospects around its pilings. (Author's collection.)

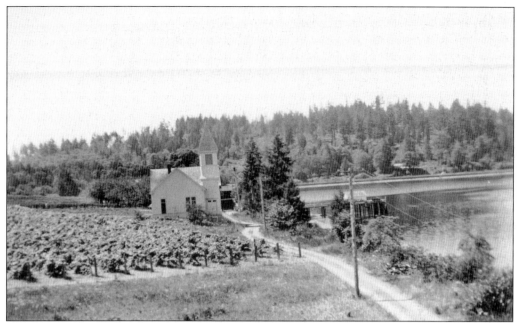

WATER TOWER VIEW. This photograph was taken from the top of the water tower built by the Millers. The well dug under the tower turned salty after the tower was built. In the 1940s, the landscape shows the Island Belle grapes grown by Anna Cook, the church, and Sylvan (Echo) Bay. (Author's collection.)

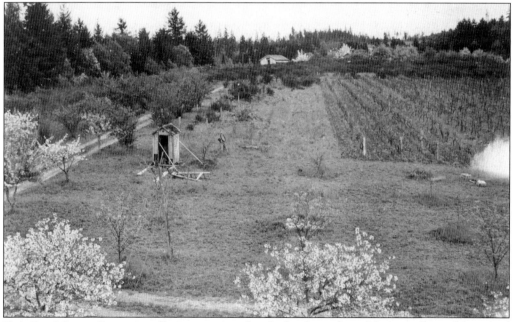

THE OLD MILLER PROPERTY. Sixty-two years after the land was cleared for agriculture, the original Miller property is reverting to Scotch broom. One of the Bloom family's barns is visible in the distance, and in front of it up to the grape rows on the right, Scotch broom fills in the area that had been acres of loganberries and youngberries. The little building is an abandoned well that turned salty. (Author's collection.)

ANNA COOK. Anna Cook was one of the last farmers on the island, raising berries and grapes until 1944. A former owner of the A. J. Miller house and acreage, she is seen here at her house next to the Sylvan Store with her dog, Jeff, and the Ericksons' white collie, Lassie. (Courtesy of the Davidson family.)

NEIGHBORS. Billy Slater (with the helmet) lived in the Bloom house (the Cranes) next to Harvey Powers Sr., who lived in the former Fitch/Wight house (the Laurels). They are sitting on the steps of the church. (Courtesy of the Powers family.)

HARVEY JR. Raised on Fox Island, Harvey Power Jr. as a young man lived in the former Fitch/Wight house (the Laurels). He joined the army in World War II, returned to Fox Island to help build Camp TaHaDoWa, and continued working in construction for Ed Erickson. He also ran an island sawmill and finally worked for the county as a road-grader operator. He also knew how to catch fish. (Courtesy of the Powers family.)

HARVEY POWER SR. Powers lived with his family in the Fitch/Wight house, better known as the Laurels. The Powers' pleasure boat was usually seen anchored in Echo Bay between Sylvan and Tanglewood Island. (Courtesy of the Powers family.)

THE NORM NELSONS. Anne and Norman Nelson lived on the beach level of the south side of Fox Island. A log chute was located on a high bank to the east of their house. Norm was a successful logger and used the chute for his logging business. Anne (Carlson) was the first white girl born on Fox Island. (Courtesy of the Nelson family.)

BILLY AND ANNA. Billy Slater lived next door on the Wheeler property of old, and he regularly visited Anna Cook in the years before he went to school. Anna Cook spent much of her time in a workshop where she painted and tinted photographs. (Courtesy of the Davidson family.)

FOUR-H PROJECT. Tom Ramsdell didn't have a pony, so he trained his prize-winning pig to carry him around his family's property. Fox Island children were very competitive with their 4-H projects as it was one of the few activities for them on the island. (Courtesy of the Ramsdell family.)

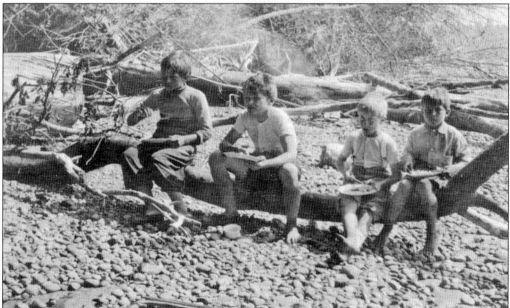

CLAYBABY BEACH. After these boys finished their lunch, they will no doubt begin searching for Fox Island's unique rock, the claybaby. This beach has clay deposits that allow the wave action to form smooth, flat clay concretions with a variety of shapes through erosion and baking in the sun on the south side of the island. Claybabies can be found decorating some of the gravestones of old-time Fox Islanders. (Courtesy of the FIHS.)

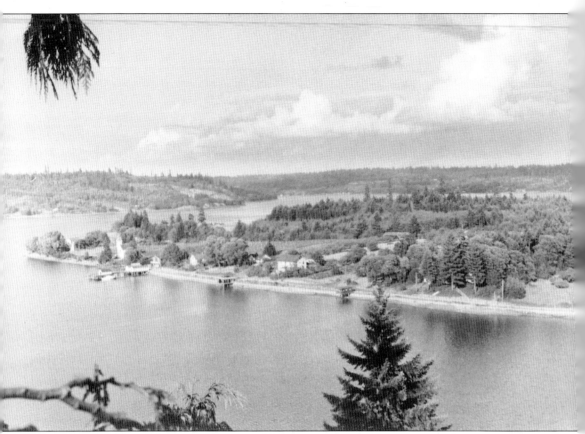

ECHO BAY, C. 1935. The settlement of Sylvan is shown as it appears on the western shore of Sylvan (Echo) Bay. Hale Pass is seen as a ribbon separating Fox Island from the mainland. (Courtesy of the Wight family.)

Four

The Bridge and After

The reconstructed Tacoma Narrows Bridge of 1950 brought prosperity to the Olympic Peninsula. Fox Island Grange officials and Pierce County commissioners thought that a bridge from the Gig Harbor Peninsula at Warren to Fox Island would prove to be equally beneficial to the island. The ferry to the island was a money-losing business, and travel to and from the island was restricted to eight trips a day. So in 1951, Senate Bill No. 9 was passed into law, authorizing Pierce County commissioners to build a Fox Island bridge. In 1953, the Washington State Toll Bridge Authority contracted for $1,450,000 to have a 1,950-foot-long by 26-feet-wide concrete bridge constructed. There are 12 concrete piers and 9 pier bents made of concrete pilings. On the east side of the bridge is a four-foot sidewalk, and there is a minimum of 30 feet of high tide clearance at the center of the span for boats to pass under. There is also a 1,500-foot bridge approach from the island to Towhead Island. The entire project was finished in 18 months, and the ferry, *City of Steilacoom*, ended its service on August 28, 1954.

At first, the hope that a bridge would be a financial boon for real estate proved to be a pipe dream. Commuters to Tacoma during the ferry years were used to riding the ferry as foot passengers, catching a bus to work, and reversing the routine after work. The bridge required commuters to own a car, license it, insure it, maintain it, and find a place to park. Thirty-five families moved from Fox Island to Tacoma because of the added expenses. Real estate values dropped, and the bridge lost more money than the ferry.

The Toll Bridge Authority came to the rescue by collecting tolls on the Narrows Bridge until both bridges were paid off. Eventually people bought island property and got jobs nearby, and the island's prosperity returned. The bridge may have lacked the charm of the ferry, but progress was allowed at a faster pace, and Fox Island was forever united with the outside world.

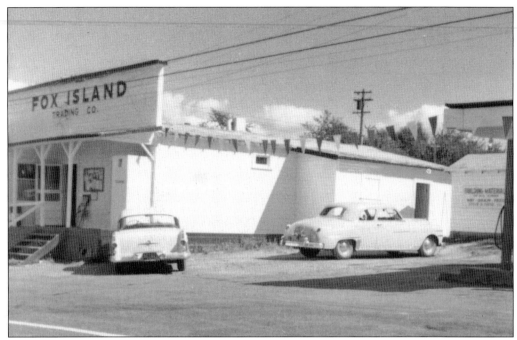

FERRY LANDING STORE. From 1921 until the ferry quit landing in 1954, the Fox Island Trading Company was the first thing ferry passengers saw upon debarking. It was the only store on the island from 1949 until 1966, when it closed and moved to its present location at the corner of Sixth Avenue and Fox Drive, the old Amen Corner. (Courtesy of the Walker family.)

INSIDE THE STORE. The trading company had just about everything a supermarket in town might have, just not in quantity. Special requests were taken by the proprietor, and by the next day, the items would be available. Throughout the years, a lunch counter, complete with stools, would periodically emerge. Customers who were prone to claustrophobia had to hold their breath and shop in spurts. Building supplies, feed, and bulky products were available in a building between the store and gas station. (Courtesy of the Walker family.)

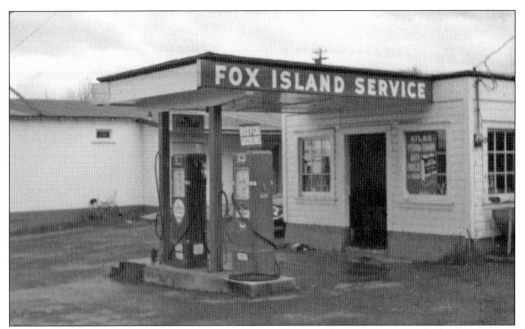

THE SERVICE STATION. Fox Island gas customers had two grades of gasoline to choose from at the trading company's gas station, located 25 feet west of the store. Service was provided by whoever was available in the store, and unlike city service stations, customers had to check their own oil and tire pressure. There was an outdoor grease pit to the west (right) of the station that saw little use. (Courtesy of the Walker family.)

GAS DOCK. After the ferry quit running in 1954, a boat-gas float was installed by the end of the ferry slip. In 1968, the old ferry landing store became a bait herring plant, and net pens full of herring were installed. The old ferry landing finally had deteriorated so much by the late 1980s that, after 70 years, all business in this area of the island ceased. (Courtesy of the FIHS.)

BRIDGE TOLLS. When the bridge to Fox Island opened in 1954, the tolls were the same as the ferry's fares. What appeared to be a good deal for those working in Tacoma, proved to create financial hardship. Commuters needed cars, insurance, and gas, plus it created a longer commute. Some workers had to move closer to their jobs, so the island's population declined for a few years. (Courtesy of the FIHS.)

STATE OF WASHINGTON
WASHINGTON TOLL BRIDGE AUTHORITY

FOX ISLAND BRIDGE
TOLL SCHEDULE
Effective September 1, 1954

Class	Type	Combination Toll	Fox Island Toll
1.	Automobile and driver (Note 1)	$.75	.50
2.	Automobile and driver, plus 1 passenger	1.10	.80
3.	Automobile and driver, plus 2 passengers	1.45	1.10
4.	Automobile and driver, plus 3 passengers	1.80	1.40
5.	Automobile and driver, plus 4 passengers	2.15	1.70
6.	Automobile and driver, plus 5 passengers	2.50	2.00
7.	Truck, gross license weight 0 to 6,000 lbs.	.75	.50
8.	Truck, gross license weight 6,001 to 12,000 lbs.	1.45	.95
9.	Truck, gross license weight 12,001 to 18,000 lbs.	2.15	1.45
10.	Truck, gross license weight 18,001 to 24,000 lbs.	2.90	1.95
11.	Truck, gross license weight 24,001 to 30,000 lbs.	3.60	2.40
12.	Truck, gross license weight 30,001 to 36,000 lbs.	4.30	2.85
13.	Truck, gross license weight 36,001 to 42,000 lbs.	5.05	3.35
14.	Truck, gross license weight 42,001 to 48,000 lbs.	5.75	3.85
15.	Truck, gross license weight 48,001 to 54,000 lbs.	6.50	4.35
16.	Truck, gross license weight 54,001 to 60,000 lbs.	7.20	4.80
17.	Truck, gross license weight 60,001 to 66,000 lbs.	7.90	5.25
18.	Truck, gross license weight 66,001 to 72,000 lbs. (Note 2)	8.65	5.75
19.	Bus, through, chartered or suburban, including driver	1.25	.75
	Passengers in each bus, each (Note 3)	.15	.10
20.	Special, unclassified units, toll to be determined at time of passage.		
21.	Vehicle, horse drawn, including driver	.85	.55
22.	Extra passengers (Note 3)	.35	.30
23.	Auto trailer, one or two wheels, not house trailer or for livestock	.75	.50
24.	Auto trailer, other than provided for above	2.00	1.45
25.	Motorcycle, with or without side car, including driver	.75	.50
26.	School bus, including driver	1.00	.75
	Passengers in school bus, each	.10	.05
27.	Pedestrian or bicycle25

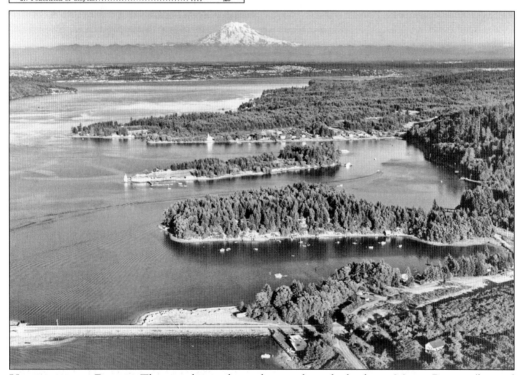

VIEW FROM THE BRIDGE. This aerial view shows the area from the bridge to Mount Rainier (beyond Tacoma) on the northwest portion of Fox Island. The community of Sylvan and Tanglewood Island in Echo Bay are easily identifiable in this 1950s photograph. The view from the bridge to Mount Rainier and the Cascades in the east, and to the Olympics in the west, is a rare visual treat. (Courtesy of the FIHS.)

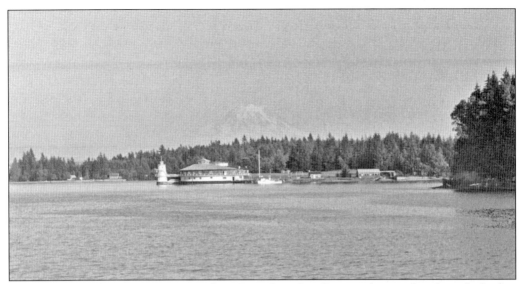

TANGLEWOOD FROM THE BRIDGE. In the 1970s, when this photograph was taken from the bridge, Camp TaHaDoWa had been closed as a camp for boys for less than five years. The camp facilities continued to be used fairly regularly by other groups, and the buildings and grounds were well maintained. The lighthouse and the pavilion have been Fox Island icons since the bridge opened in 1954. (Courtesy of Dr. Ken Rasmussen.)

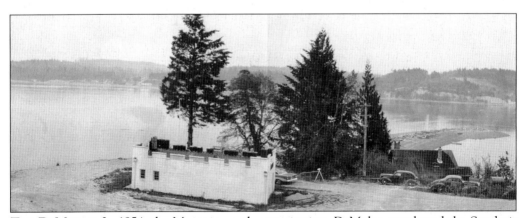

THE DEMOLAY. In 1954, the Masonic youth organization, DeMolay, purchased the Sandspit property at the west end of Fox Island. A cinder block building was constructed, and the former potlatch and picnic place was closed to the public. (Courtesy of the FIHS.)

THE ERICKSONS. Doshia and Ed Erickson came to Fox Island from North Dakota in 1930 with their teenaged daughters, Esther and Virginia. They bought the Sylvan Lodge from the Wines family and wired it for electricity, which came to Fox Island in 1931. Doshia was a popular hostess, and Ed was Master of the Grange, ferry purser, and builder. (Courtesy of the Erickson family.)

THE FRED NICHOLS FAMILY. Col. Fred Nichols and his wife, Emily, were a familiar couple of Fox Island. Colonel Nichols had roots in the Hope area of the island going back to 1921, when he was the postmaster of Hope. In the late 1920s and early 1930s, he operated a building supply business at Fairmont and engaged in logging with Norm Nelson until World War II, when he achieved the rank of colonel in the U.S. Army. After that, he formed the Fox Island Water Company. (Courtesy of the Nichols family.)

MOVERS AND SHAKERS. Seen working on building the Fox Island Historical Museum in 1980 are, from left to right, islanders George Miller (of Macklin), Dr. Ernie Karlstrom (of Sylvan), and Eleanor Kibler (of Fox Point). (Courtesy of the Miller family.)

MUSEUM BUILDERS. In 1979 and 1980, a group of dedicated Fox Islanders helped build the Fox Island Historical Museum. From left to right are (first row) Fred Nichols, Gene Fisher, Everett Hill, Ernie Karlstrom, and George Miller; (second row) Mitch Curtis, Jim Menzies, Norm Zumhoff, Harold Eister, and unidentified. (Courtesy of the Miller family.)

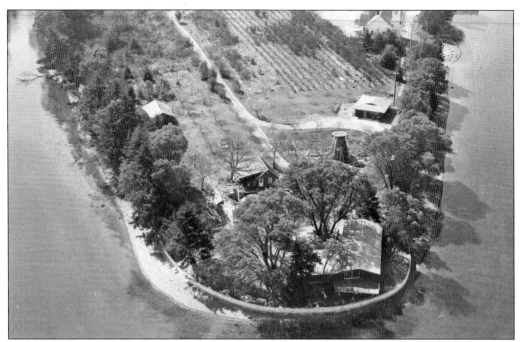

ACRES OF EDGERS. In 1956, the former Miller home was torn down and a new home was constructed on the point by Fox Islanders Ed Erickson and Harvey Powers for Dr. Kenneth and Lois Edgers. The roof on the left is the Millers' 1889 (hen) house. On the right are the water tower and a small house from 1955. The remnants of Anna Cook's grapes and the church can also be seen. (Author's collection.)

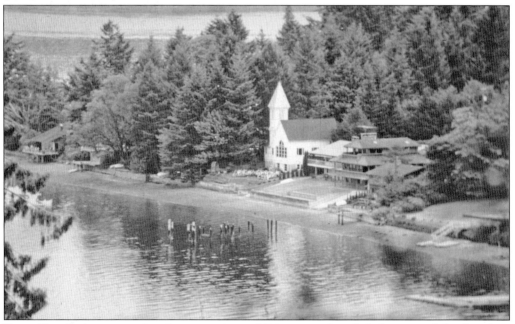

ECHO BAY. Eighty years after the community of Sylvan was founded, the view of the shoreline is only recognizable because of the Fox Island Congregational Church (now the United Church of Christ). (Courtesy of the Seely family.)

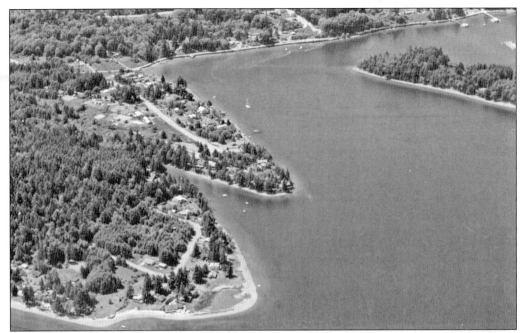

AERIAL VIEW OF SYLVAN, 1980s. By 1980, practically all the signs of Sylvan's past had vanished. The bulkhead road built 1906–1909 is still visible along the south shore of Sylvan (Echo) Bay. A portion of a new road from the bridge, Island Boulevard, can be seen toward the top of the photograph. New houses appear like barnacles on the Sylvan landscape. (Author's collection.)

GOVERNOR RAY. From 1976 to 1980, Gov. Dixie Lee Ray lived in the Governor's Mansion in Olympia during the week, but on the weekends, she returned to her home on Fox Island. Her home was on the south side overlooking Carr Inlet toward McNeil Island. (Courtesy of the FIHS.)

DIXIE. Governor Ray didn't lord over her Fox Island neighbors and participated in the Fox Island Fair activities as a "regular" person. She was an accomplished wood carver of Native American designs, and she raised flowers and vegetables to display. She also raised pigs, which she named after newspaper reporters. She would announce to the press who she was having for supper when a pig was butchered. (Courtesy of the FIHS.)

GOVERNOR DIXIE AT THE FAIR. Gov. Dixie Lee Ray, of the south side of Fox Island, was the island's claim to fame in the 1970s and 1980s. She is seen here with one of her French poodles at the annual Fox Island Fair. She was a friendly and enthusiastic participant in Fox Island activities. (Courtesy of the FIHS.)

Five

Recently

After the tolls and tollbooth were removed from the bridge in 1964, free access to Fox Island was more enticing to many people who were attracted to an island. The primary road on the island shifted away from the shoreline and to the center, as did the store and post office. Soon all the roads were paved and posted with street and traffic signs.

The two-room Fox Island School closed as a school but has been used and maintained as the Nichols Center, for use by the Fox Island community. Camp TaHaDoWa closed as a camp for boys in 1966 but was used by different groups for several years until it was sold to four individual property owners. The main building and lighthouse, icons for the island, are now in disrepair. The church on the water is now a wedding chapel. The Navy Barge is no longer a barge but rather a large land-based facility.

The only structure left on Miller's Point is the water tower from 1890. Where there was one house and a chicken house on 12 acres, there are now 14 houses. There are only two original houses and one boathouse left in the 56.5-acre Sylvan community; all have been remodeled. Ketner's Point has one remaining original house.

New to the island are a small apartment complex, a condominium community, two gated communities, a fire station, a historical museum, a yacht club, a United Church of Christ church building, and a large Fox Island Christian and Missionary Alliance church building.

In 1856, Fox Island's population was one. In the ensuing 150-plus years, the population has increased to nearly 3,000. In the community of Sylvan, the entire 56.5 acres was sold to a logger, Josh Raines, for $118 in 1881. Today this property is valued at many millions of dollars.

It will be interesting to know just how much more Fox Island can develop in the next 150 years.

THE 100TH ANNIVERSARY MARKER. This monument, which is a replica of the Washington Monument in Washington, D.C., was erected in the Fox Island Cemetery in 1989 to commemorate the 100th anniversary of Washington's entry into the Union as the 42nd state. Historian George Miller is attaching a plaque marking the location of a time capsule to be opened in 2089. (Courtesy of the Miller family.)

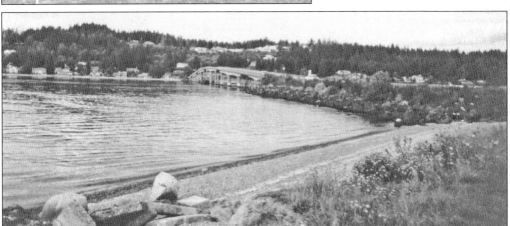

THE BRIDGE. Construction of the 1,950-foot concrete Fox Island Bridge began in 1953, and it was open for business in August 1954. The tollbooth collected money and tickets until 1963, when both the Tacoma Narrows and the Fox Island Bridge bonds were paid off. The only things that have changed in the 53 years of its existence are the tollbooth (gone) and the tollbooth plaza on the end of Towhead Island (now a boat launch ramp). (Author's collection.)

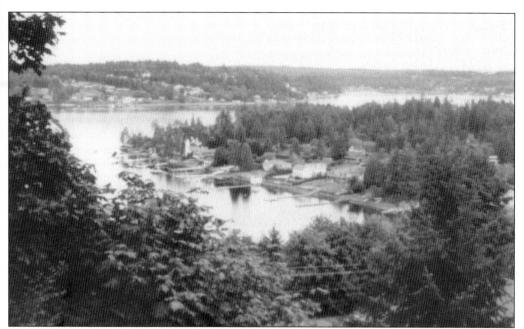

SYLVAN (ECHO) BAY, 2007. The Fox Island Congregational Church (now called the Wedding Chapel on Echo Bay), built in 1900, still stands, as does the (remodeled) Laurels built in 1904. Otherwise all the homes and floating docks that fill up the western shoreline of Sylvan (Echo) Bay have been added to the community of Sylvan over the past century. (Author's collection.)

AMEN HILL, 2007. This view looks down the Amen Hill of the early 20th century, now called Sixth Avenue. At the end of this road is the old Fox Island Congregational Church, which is now a popular wedding chapel. On the right is the Fox Island Trading Post, which has been in this location since 1966, after it moved from its location at the old ferry landing. The current store has competitive gas prices and a delicatessen snack bar. (Author's collection.)

AMEN CORNER, 2007. The corner where Sylvan church parishioners used to exclaim "Amen!" upon reaching this muddy hilltop corner was a single-lane dirt track with nothing but trees lining its sides. Now, besides the store and gas station, one sees a coffee stand, the post office (since 1964), and the telephone exchange switching station on the left. (Author's collection.)

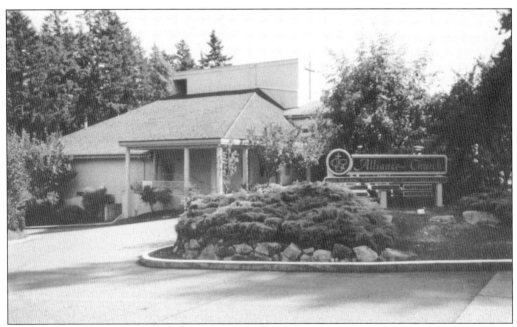

THE CHRISTIAN AND MISSIONARY ALLIANCE CHURCH (C&MA). When this church denomination first met in 1983, it was in the former Fox Island School building (Nichols Center). In 1985, five acres was purchased across the road and 75 yards north of the trading post. In 1986, the foundation for the church was completed, and the 350-seat sanctuary was ready by the summer of 1989. The pastor of the church was Andre ("Andy") Snodgrass. (Author's collection.)

THE C&MA CHURCH EXPANSION. It was decided in 1997 to add 14,000 square feet onto the existing 19,000-square-foot structure, making it the largest building on Fox Island and the only one to have an elevator. The finished church building was dedicated in 1999 by Dr. Andy Snodgrass, the only pastor the church has had. (Author's collection.)

THE UNITED CHURCH OF CHRIST. The original Fox Island Congregational Church became the United Church of Christ in 1961 when the Congregational-Christian and the Evangelical and Reformed Churches joined together. In 1999, the Fox Island church on the water decided to build on property it owned across the road from the Fox Island Cemetery. (Author's collection.)

SOUTHERN SIDE OF UNITED CHURCH OF CHRIST. The 1900 church faced Sylvan Bay and Hale Pass to the west, with windows on the south side to maximize natural light in the days before electric lights. The new church faces the south, overlooking Carr Inlet. The church was completed and then dedicated by Rev. B. J. Beu in 2000. Reverend Beu has been the church's minister since 1995. Since the Fox Island church's 1892 founding, 13 pastors have officiated. (Author's collection.)

THE ACHESON CABIN. The Acheson family built this log cabin in 1908 at the far eastern end of Fox Island on Fox Point (near the Concrete Dock). Lila Acheson taught school at the Benbow School in 1910 and later married DeWitt Wallace. The Wallaces went on to found *Reader's Digest*. The Wallaces decided to contribute most of the money to restore the cabin and build the Fox Island Historical Museum. The cabin was moved to the museum site in 1977. (Author's collection.)

BOB MONSEN'S MODEL T. Dr. Robert Monsen and his son Forest are parked in front of the Fox Island Historical Museum in one of Bob's Model Ts that he has restored from a collection accumulated over the years. At one time, Dr. Monsen had a Model T Ford agency, just for the fun of it. (Courtesy of the Monsen family.)

FIHS HISTORICAL CRUISE. Starting in the early 1990s, the Fox Island Historical Society would charter a tour boat from Tacoma to carry Fox Island historical buffs around the island to examine sites of the past. Fox Islanders George Miller, Don Edgers, Dave McHugh, and Ward Hunt have been narrators for the cruises. (Courtesy of the FIHS.)

Across America, People are Discovering Something Wonderful. Their Heritage.

Arcadia Publishing is the leading local history publisher in the United States. With more than 4,000 titles in print and hundreds of new titles released every year, Arcadia has extensive specialized experience chronicling the history of communities and celebrating America's hidden stories, bringing to life the people, places, and events from the past. To discover the history of other communities across the nation, please visit:

www.arcadiapublishing.com

Customized search tools allow you to find regional history books about the town where you grew up, the cities where your friends and family live, the town where your parents met, or even that retirement spot you've been dreaming about.

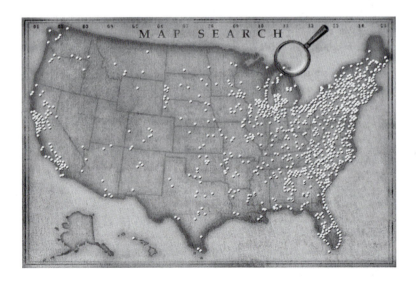